THE TREASURES OF THE
NANJING MUSEUM

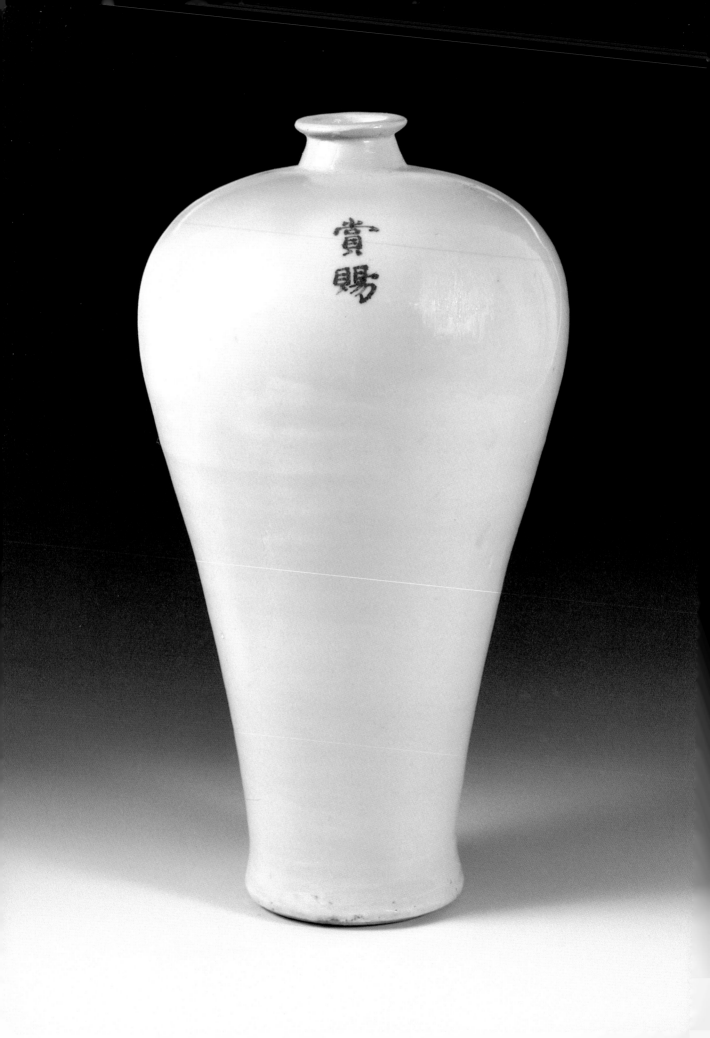

THE TREASURES OF THE NANJING MUSEUM

XU HUPING

London Editions
The Nanjing Museum

First published in 2001 by London Editions (Hong Kong) Ltd
24 Wong Chuk Hang Road, Aberdeen, Hong Kong

Sold and distributed in the USA and Canada by
Antique Collectors' Club, Market Street Industrial park,
Wappingers Falls, NY 12590

Sold in the Rest of the World, outside the USA and Canada, and
The People's Republic of China, by Scala Publishers Ltd,
140a Shaftesbury Avenue, London WC2H 8HD

ISBN 962 8621 5 1 3

General Editor: Xu Huping
Photographers: Guo Qun, Han Qiang, Guo Lidian
Translated from the Chinese by: Li Yaqing
Specialist editor: Dr Susan Whitfield
Designed by: Anikst Design, London

Printed and bound in China by China Translation and Printing Services Ltd

CONTENTS

Introduction 6

1 Bronze and Gold 18

2 Jade 32

3 Ceramics 44

4 Lacquer 88

5 Works of Art 98

6 Painting and Embroidery 112

7 List of Plates 126

Nanjing Museum has a history dating back nearly seventy years from the establishment of the Planning Department for the Central National Museum in 1933. The original plan for the museum comprised three galleries: Natural History; Humanities; and Technology. The first phase of construction of the museum — the construction of the Humanities Gallery — started in 1936, shortly before the War of Resistance against Japan broke out. It was not until the end of 1947 that construction was completed.

Forty-six years later, in 1993, at the 60th anniversary of the founding of Nanjing Museum, the government of Jiangsu Province decided to begin the second phase of construction. The plan was to build a new Art Gallery (originally called the Technology Gallery) at the south east corner of the former Humanities Gallery (now named the History Gallery). With government backing and widespread enthusiasm, as well as the assistance and sponsorship of overseas Chinese , the project was completed within six years and opened to the public on 26 September, 1999.

ART GALLERY OF NANJING

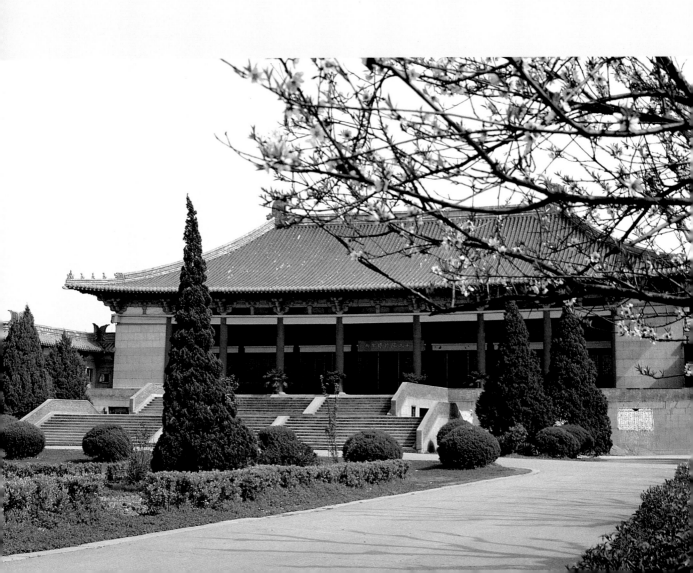

The newly built Art Gallery covers a total floor space of 17,000 square metres. It conforms to the Liao dynasty architectural style of the History Gallery, and the two buildings therefore form a harmonious unit. High above the entrance of the Art Gallery hangs a plaque inscribed in gold with a quotation from a Tang dynasty work in the calligraphic style of the 'Zheng Wengong Tablet' (an inscribed stone dating from 511). The plaque reads: 'Wuhua Tianbao' (Earth's Splendours and Heaven's Treasures).

The building has two storeys, housing eleven permanent exhibitions — treasures, embroidery, folk art, lacquer, jade, porcelain of the Ming and Qing dynasties, bronze, pottery, calligraphy and painting, modern art, and sculpture — and the Chan Chi-fat art gallery for temporary exhibitions.

Gallery Plan

1ST FLOOR (GROUND)

A Folk Art Hall
B Bronze Hall
C T.T.Tsui Porcelain Hall
D Tse Tze-ho Treasures Hall
E Pottery Hall
F Offices
G Kwan Tze-tong Coffee Shop
H Projection video centre
I Lecture Hall

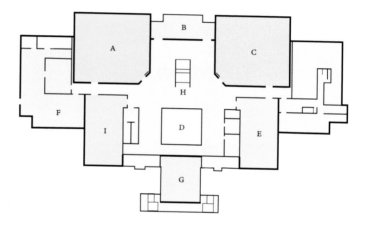

2ND FLOOR

A Contemporary
 Arts Hall
B Textile and
 Embroidery Hall
C Run Run Shaw Jade Hall
D Ancient Calligraphy
 and Painting Hall
E Lacquer Hall
F Chan Chi-fat Costumes and
 Accessories Hall

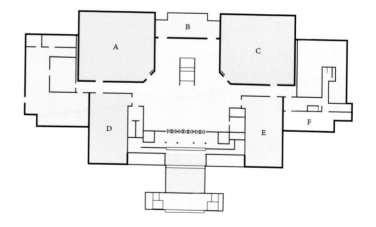

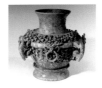
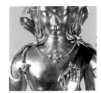

Built with the subscriptions of Mr. Tse Siu-bong, a well-known figure in Hong Kong, and named after Mr. Tse's father, the round treasure hall is at the centre of the Art Gallery. The finest gold, silver, jade, bronze and porcelain artefacts of Nanjing Museum are exhibited here. For example: 38 gold articles, including a realistic animal model, excavated at Nanyaozhuang; an exquisitely made gold Buddha statue fashioned for the Qing emperor by the Imperial Palace Workshop; a jade *cong* with animal mask designs excavated in 1995 at Wujinsidun; a white jade cup excavated in 1995 from a Han period tomb at Shizishan, Xuzhou; and a gilded bronze ink-slab box in the shape of a beast, found in 1970 in a Han tomb at Tushan, Xuzhou. All these are listed as National Treasures.

The 38 gold articles, excavated in the spring of 1982 from an underground storage room at Nanyaozhuang, Xuyi County, Jiangsu Province, are the most famous. They include a gold animal, a gold and silver inlaid solid bronze pot, and gold currency, including gold *Yingyuan* (coins from Ying, the capital of the State of Chu in the Warring States period), and 30 gold ingots in the shape of horseshoes and discs. When excavated, the money was in a gold and silver inlaid solid bronze pot with the gold animal as a stopper. The discovery of Nanyaozhuang gold artefacts caused a sensation world-wide because of their rare quality.

The gold animal — 17.8 cm long, 16 cm wide and 10.2 cm high and depicting a leopard — weighs nine kilogrammes and is the heaviest of all the ancient gold objects excavated to date (catalogue no. 6). The solid bronze *hu* vessel is 24 cm in height (catalogue no. 5). Its outer surface is decorated with openwork interlocking designs and exquisite inlaid work of gold, silver and turquoise that shows the consummate technology of metal casting at this time. The inner rim of the mouth and both inside and outside of the circular foot are incribed with the history of the war between the states of Qi and Yan. Qi attacked Yan in the fifth year of King Xuan's reign [566 BC], and the Qi general, Chen Zhang, captured the Yan capital. The vessel is therefore known as the 'Chen Zhang round *hu*'. There are only two such vessels and the other was taken abroad many years ago.

Yingyuan, horseshoe-shaped and flat disc shaped gold ingots were all currencies during the Warring States period and the Han dynasty. In this excavation, we discovered 54 *Yingyuan* weighing 610kg, making them the largest and best-preserved examples. Other treasures on display in the gallery include a gilded silver belt hook found in 1965 at Sanlidun, Lianshui County in Jiangsu Province, a unique ancient treasure.

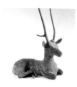

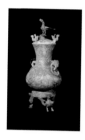
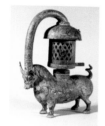

BRONZE HALL

The Bronze Age in China spanned the period from the Shang and Zhou dynasties to the Warring States and bronze casting developed to a very advanced level, primarily using ceramic moulds but with lost wax method also employed at times for very intricate designs. Previously, scholars were interested mainly in the bronze wares of the Central China plains and knew little about those produced further south in the Yangzi River basin. This exhibition seeks to expand the borders of scholarship by showing bronzewares produced during the Warring States period in this southern area — present-day Jiangsu and Zhejiang provinces — as exemplars. The food, wine and water containers and musical instruments on display therefore all witness the succinctness, liveliness and elegance of southern bronze wares.

Of special note from the bronze collections, exhibited in the Treasures Hall is the Eastern Han period bronze ox lamp excavated in 1980 from Tomb No 2 at Ganquanshan, Hanjiang County, Jiangsu Province, a masterpiece of the southern artisans (catalogue no. 7). It is 46 cm high and 36.4 cm long. The lamp stand is an ox and a smoke tube leads from the crown of his head to the lamp shade. When the lamp is lit the hollow body of the ox is filled with water. The lamp black then travels along the tube and is filtered by the water, making for a very clean burning lamp. This ingenious design therefore has considerable technological value. The vigorously modelled ox's body is inlaid with fluid silver designs.

Other exhibited bronze treasures include an early Western Zhou period rhinocerous horn wine cup with phoenix designs, excavated in 1954 at Yandunshan, Dantu County and a tripod ladle with *kui*-dragon designs excavated in 1957 at Yancheng; and several tripods of the late Spring and Autumn period, excavated at Beishan, Dantu County, Jiangsu Province. These are all rare cultural treasures.

JADE HALL

The designers of the Jade Hall have exploited modern technology to recreate Tomb 3 at Sidun, Wujin County and Tomb 77 at Zhaolingshan, both in Jiangsu Province. This is intended to transport the visitor back in time, giving them a feel of the original burial sites. This type of exhibition for jade is unprecedented in China.

The Neolithic Liangzhu Culture jade *cong* with animal mask designs (catalogue no 17) was excavated in 1978 from Tomb 4 at Sidun, Wujin County, and reveals some of the special features of the Nanjing Museum collections. It has the usual square cross-section of Neolithic *cong* with a tubular bore. The corners are decorated with four groups of animal mask designs carved in fine lines, each group consisting of eight mask designs. The designs are minimally delineated

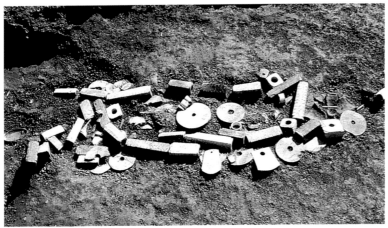

Jade Hoard
Neolithic, Liangzhu
Culture, 2500 BC
Tomb 3, Sidun, Wujin
County, Jiangsu Province
This hoard, found in the
tomb of a young man of
about 20, comprises over 120
pieces of jade, stone and
ceramics, including over 50
cong and *bi*, arranged in
sequence around the corpse.
The young man must have
been from an illustrious fam-
ily holding considerable
power, whether monetary,
spiritual, military or family.

with the top two horizontal strokes indicating the feather headdress of the human behind the mask, while the projecting angles and circle below indicate his face. The top strokes and the sketches below constitute a complete but simplified ani-mal mask. This *cong* has been unanimously recognized as an exemplar of Liangzhu Culture jade by China's archaeologists.

LACQUER HALL

The exhibits in this hall are divided chronologically into works of the Han, the Song, and the Ming and Qing dynasties. Each of these three sections represents a high point in Chinese lacquerwork. Lacquerware is most distinctive in the south of China where lacquer trees grow. All the exhibits in the Han dynasty section have been excavated. For example, the *zun* — a wine vessel — with the coloured depiction of a harem, was donated to the Central National Museum by a famous palaeographer, Mr. Shang Chengzuo, having been excavated during the Japanese war in Changsha, Hunan Province. This vessel is 14.5 cm high with a diameter of 14 cm. It is double-layered and cylindrical in shape with a lid and three feet. It is an imitation of Han period bronze *zun*. Eleven beautiful women are depicted in dif-ferent coloured layers of lacquer, reflecting the superb drawing skills of the lac-quer artisans of the time.

Many lacquer exhibits in this hall are the works of the imperial palaces or of famous artists throughout Chinese history. The Han dynasty black lacquer dish, excavated in 1963 from Tomb No. 1 at Sanyangdun, Yancheng, Jiangsu Province is one example. The two characters 'Da Guan' are painted in the centre of the tray and, at the brim, 'Shanglin'. 'Da Guan shi' was the Banquets Office in the Court of

Imperial Entertainments, responsible for preparing meals for the palace and court. 'Shanglin' was the imperial park, the emperor's hunting ground during the spring and autumn seasons, where all kinds of animals were reared.

Jiang Qianli was famous for his lacquer vessels inlaid with mother-of-pearl during the late Ming and early Qing dynasties. He was equal in fame with contemporary artists such as the exceptional bamboo sculptor Zhu Songlin and the purple earthenware teapot maker Shi Dabin. One of Jiang Qianli's mother-of-pearl lacquer dishes with a design of the West Chamber is exhibited in this hall.

Other lacquerwares used by the Ming and Qing imperial palaces and exhibited here include a round lacquer carved box with landscape and figures marked 'made in the Qianlong reign period of the Great Qing' and a lacquer carved box made to hold Buddhist sutras.

POTTERY HALL

Most of the exhibits in the pottery hall were excavated by several generations of archaeologists from the Nanjing Museum. Among the exhibits are a sheep-shaped red clay stand for a coin tree, excavated in 1941 from a Han dynasty tomb at Pengshan, Sichuan Province; a pottery dancing figure excavated in 1950 from two Southern Tang tombs at Zutangshan, Nanjing; a mould printed brick painting of 'Seven Wise Men of Zhulin and Rong Qiqi' of the Southern Dynasties, excavated in 1960 at Xishanqiao, Nanjing; a Dawenkou Culture pot excavated in 1966 at Dadunzi, Pi County, Jiangsu Province; and pig-shaped pottery pots of different sizes excavated in 1992 at Longqiuzhuang, Gaoyou, Jiangsu Province.

The mould printed brick painting of the seven wise men is a large and exquisitely executed work that portrays well-known figures of the Six Dynasties and the Spring and Autumn period. The appearance and charm of the figures are vividly depicted. Prior to this discovery, there were probably no extant figure paintings from the Six Dynasties period and this work thus provides a vital link in the history of Chinese painting. The straight and graceful modelling and the exquisite workmanship make it an indisputable representative work.

Also in the gallery is a unique glazed model of a famous pagoda decorated with mould printed relief Buddhist symbols such as lions, tigers and apsaras. According to historical sources, the Kangxi and Qianlong emperors both climbed this pagoda during their inspection tours to the south of China. In 1854, during the Taiping Rebellion, this pagoda, known both at home and abroad, was totally destroyed. The only survival, a glazed arched gate has become a precious historical witness to its destruction.

PORCELAIN

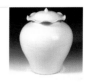

This hall for exhibiting the porcelain of the Ming and Qing dynasties was constructed with the generous support of Mr T.T. Tsui and named after him. Mr Tsui is a Hong Kong collector and industrialist. The porcelain of the Ming and Qing dynasties is foremost in the collections and includes fine examples of wares produced under successive reigns of Ming and Qing emperors. A summary list is given below:

Ming Dynasty Porcelain:
Hongwu reign period large porcelain dish in underglaze red-copper
Yongle reign period blue and white flat porcelain pot
Xuande reign large blue and white porcelain incense burner
Zhengtong reign period large blue and white peacock and peony *meiping*
Chenghua reign period yellow-glazed dish
Hongzhi reign period yellow-glazed double-eared *zun*
Zhengde reign period bowl with dragon designs in contrasting colour
Jiajing reign period large blue and white pot with dragon designs on cover
Longqin reign period blue and white bowl
Wanli reign period blue and white double-eared vase
Chongzhen reign period blue and white writing-brush washer

Qing Dynasty Porcelain:
Shunzhi reign period blue and white incense burner
Kangxi reign period blue and white longevity *zun*
Yongzheng reign period large blue and white vase with dragon designs
Qianlong reign period hundred deer *famille rose zun*

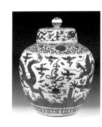

The treasures listed above were produced by the imperial kilns under emperors of many generations. Some of them are the sole extant examples. For example, the underglaze red-copper *meiping* with cover decorated with pine, bamboo and plum designs from the Ming dynasty Hongwu reign period is the only intact vase of its kind in the world (catalogue no. 38). It was excavated in March 1957, from the joint burial tomb of the imperial son-in-law and military leader Song Hu and his wife, Princess Ancheng, at Xianglongshan, Dongshanqiao, Jiangling County, Jiangsu Province. Another such example is the large porcelain incense burner with mountain (symbolizing longevity) and sea (symbolizing good fortune) designs made in the Xuande reign period (catalogue no.44). The burner is 58 cm high and covered with a design of rolling sea waves painted in white on a blue ground. It can only be matched by the large blue and white porcelain incense burner made in the Ming dynasty Yongle reign period and now held in the National Palace Museum in Beijing.

ANCIENT CALLIGRAPHY AND PAINTING HALL

The land of rivers and lakes in Jiangsu and Anhui provinces with its fertile soil and mild climate is a large agricultural producer. Many famous Chinese painters and painting schools came from this region and therefore the paintings and calligraphy exhibited in this hall could be seen as an encapsulated history of Chinese painting including, as they do, examples in the Academy style by the Song emperor Huizong, works of the famous Wu School of Painters of the Ming and Qing dynasties, works of the Eight Eccentrics of Yangzhou, and the famous Eight Masters of Nanjing. Among them, the most representative pieces are:

'Fighting Mynahs' by the Huizong emperor
Huang Gongwang's 'Spring in High Mountain Ridges' (Yuan dynasty)
Ni Zan's 'Bamboo Forest and Ancient Trees' (Yuan dynasty)
Zhou Chen's 'Seeing Off a Visitor at the Cottage Gate' (Ming dynasty),
Qiu Ying's 'The Flute Player by the Pine-Tree Stream' (Ming dynasty)
Xu Wei's 'Three Friends' (Ming dynasty)
Dong Qichang's 'Delightful Serenity by the Pine-Tree Stream' (Ming dynasty)
Chen Hongshou's 'Elegy to the Plum Blossom' (Ming dynasty)
Gong Xian's 'Mountains in Summer Rain' (Qing dynasty)
Zhu Da's Landscape scrolls (Qing Dyasty).

'The Scroll of Mynahs' by Zhao Ji, the Song dynasty Huizong emperor, is in the Academy style of painting, of which there are very few extant examples (catalogue no.95). Measuring 88.2 by 52 cm it shows three mynah birds, one, perched on a pine tree banch, twittering excitedly in response to the two other fighting mynahs below it. The birds are vividly portrayed in vigorous strokes. Above the picture, there is a poem written by the Qing emperor Qianlong which can be read on page 113 below.

There are also several imperial seals on the scroll such as 'Treasure for the Imperial Appreciation', 'Old Emperor', 'Treasure for an Octogenarian's Memory', 'Skillfully Examined in San Xi Hall' and 'Benefits for Posterity'. They show that this imperial, scroll gave enjoyment to the emperor.

'The Flute Player by the Pine-Tree Stream' by Qiu Ying (c. 1495-1552), an artist of the Wu Painting School (named after Wu County in Jiangsu Province, home to many of the painters), measures 116.4 x 65.8 cm and shows a hermit living in a tranquil secluded valley with mountains whose peaks rise above the lower wooded slopes. Knarled ancient pine trees line the banks of the stream and a cottage can be seen dimly in the forest. In the bright moonlight a barefoot hermit is playing a flute in a boat on the stream.

'Mountains in Summer Rain' is 141.7 x 57.8 cm and typical of Gong Xian's style. Gong Xian (c. 1620-89) was one of the 'Eight Masters of Nanjing'. The painting portrays mountains and a village shrouded in mists. Using simple and vigorous strokes, the painter used layers of ink to produce this work.

TEXTILE AND
EMBROIDERY HALL

The Yangzi River delta, a land of agriculture and fishery, was also a centre for production of textiles and embroidery. The exhibits in this hall concentrate on the outstanding achievements of these industries in Nanjing and Suzhou, and include silk, embroidery, *kesi* tapestry, costume and accessories.

Silk has always been one of the characteristic products of southern Jiangsu. The Qing court established official agencies in Nanjing and Hangzhou responsible for producing silks for the imperial court. On exhibition here is a piece of silk from a warehouse in Nanjing. Patterns of cracked ice and plum blossoms are woven in gold threads on the ground of green silk. It is both ornate and elegant, a defining characteristic of the silk products of this area. At the top is an identification mark reading 'Jinling Tu Dongyuan Yuji Kujin' (The Eastern Treasure Warehouse of Nanjing). It is typical of Nanjing brocade.

Embroidery appeared as early as the Shang dynasty (17th – 11th centuries BC), but was mainly seen on clothes. From the Song dynasty, purely aesthetic embroidered objects started to be made. 'Luxiangyuan Gu Embroidery' of the Ming dynasty displays the considerable artistic achievements of this handicraft with 'Seven Sages at the Bamboo Forest' being representative. Four major regional schools developed in the Qing: Su(zhou), Yue (Guangzhou), Shu (Chengdu) and Xiang (Changsha). These four schools contended for supremacy in novelty and beauty and Su embroidery, in particular, became very influential.

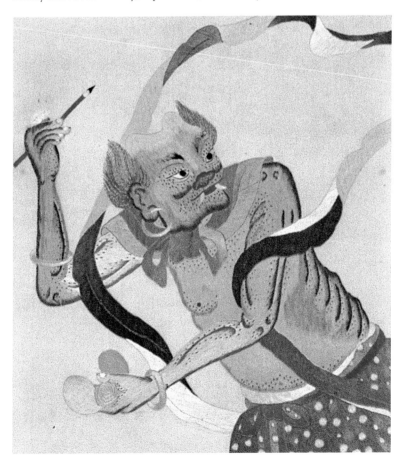

Embroidered Picture of the God of Literature, Qing dynasty, Qianlong reign, detail. (catalogue no.101)

COSTUMES AND ACCESSORIES

With the development of sophisticated dyeing techniques and the extensive use of embroidery and tapestry, clothing had long been more than simply cover for the body and protection against the elements: it had aesthetic and decorative functions and fashion flourished with the Jiangnan region (Jiangsu and Anhui provinces) as a centre. A typical example from the collections is an embroidered green satin woman's jacket from the Qing dynasty. The body of the jacket is 110 cm long and the sleeves 140 cm. It has a central fastening, upright collar and straight sleeves. The shell fabric is green satin with peonies and butterflies embroidered on the upper part. The peonies are using knot stitch to give them a three dimensional feel. The lower border carries a design of sea and cliffs, above which fish and lotus are embroidered in twisted gold thread. The whole jacket is refined and free from vulgarity.

FOLK ART HALL

Since its founding, Nanjing Museum has attached great importance to researching folk culture and to acquiring representative artefacts. Thanks to the efforts of several generations of experts, it is a stunning collection. The manner in which the items are exhibited is also original, being divided into the following main sections:

1. folk dress – clothes of the river and lakes region of Jiangsu Province, silver ornaments and indigo prints.
2. articles used in daily life – cakes and biscuits moulds, tobacco pipes, hookahs, lamps, lanterns, heaters and fans.
3. implements and tools for agriculture, carpentry, spinning, weaving and woodblock printing.
4. props for folk entertainment – shadowgraph — and masks.
5. kites, toys, and musical instruments.
6. ritual articles – paper horses, face paintings for public entertainment on festival days, wooden *Naxi* script tablets, and paper streamers.
7. festival ornaments – New Year paintings, paper-cuts, and Wuxi clay figurines
8. folk sculpture – Suzhou brick carving, folk stone carving, and bamboo and wood carvings.

CONCLUSION

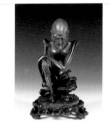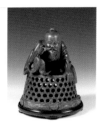

Completion of the new Art Gallery of Nanjing Museum has given China another large art museum conforming to the highest international standards, following the building of the new Shanghai Museum. In Nanjing, a wide and varied array of splendid historical relics are exhibited to the highest technological standards for the visitors. Nanjing Museum, an institute nearly seven decades old, can now enter the third millennium with great enthusiasm, presenting a new face to the world.

Xu Huping

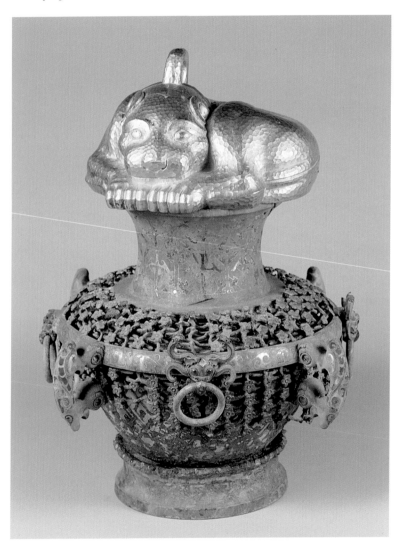

Gold and Silver inlaid Bronze *Hu*, Warring States period, with gold animal stopper, Western Han dynasty. This bronze pot contained a horde of gold *Yingyuan* as well as horse-shoes and discs. The gold animal acted as a stopper. (see nos. 5 and 6)

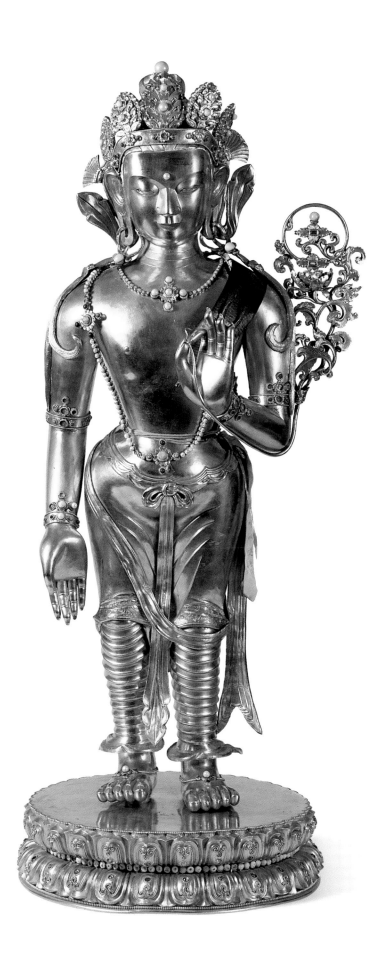

Gold Bodhisattva
Qing dynasty
(see no. 13)

BRONZE AND GOLD

China was one of the earliest civilisations to develop bronze smelting technology and the ritual vessels and musical instruments of the Shang and Zhou dynasties are of the highest quality. They were generally made from ceramic casts but the lost-wax method was used in some cases of very intricate designs.Gold and silver were mainly used for currency but some artefacts were produced and were highly valued. The bronze, gold and silver articles produced in the region south of the Yangzi River play an important role in China's technological history and display the ingenuity and wit of the local people.

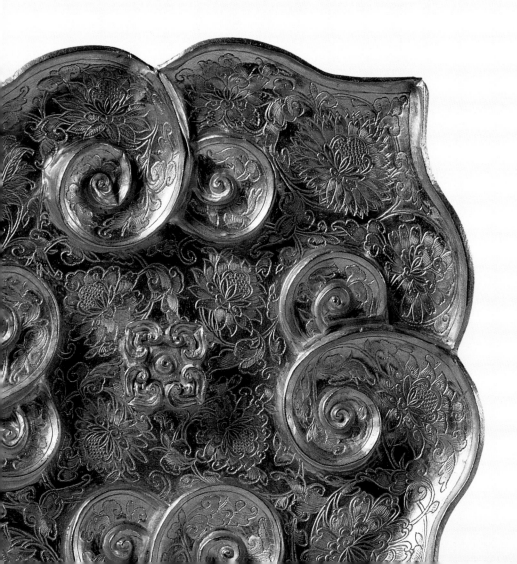

1

Large Bronze *Jian* with Phoenixes
Western Zhou period
20.4 x 84 cm
From a Western Zhou dynasty tomb, at Yi Zheng Poshankou ,
Jiangsu Province

According to historical records, the *jian* is a vessel holding water or
ice with two or four handles and which was probably used for wash-
ing during imperial rituals. This example has two ring handles and a
circular foot. The inside is decorated with a cord pattern. The four
birds on the rim are phoenixes, representing peace, happiness and
good fortune. The vessel was excavated from an imperial tomb.

2

Bronze *Hu* Inlaid with Gold and Silver
Warring States period
Height: 74 cm

The *hu* was a ritual vessel used for holding wine in the Shang and Zhou periods. Three birds support the circular foot of this example on the tips of their wings. The bodies of the birds are decorated with a feather design and therefore probably represent the legendary *Dali* bird. The body, the rim and the shoulder of the pot are all decorated with a ribbon design. The shoulder and the neck are decorated mainly with designs of clouds-in-triangles and bats, a symbol of prosperity. The belly of the pot is embellished with a lozenge design. The spaces between the various patterns are inlaid with turquoise and bronze bubbles gilded with gold and silver.

Three fledglings perch on the rim with their wings spread as if trying to fly. A crane — a symbol of longevity — stands atop a five-petal plum blossom knob on the middle of the lid. Its neck is extended and wings unfolded as if singing loudly. The decorative birds lighten the cumbersome structure and the rhythmic patterns make this bronze pot both refined yet luxurious. The vessel was cast in pieces and welded together. This and the inlay and gilding work demonstrate the high level of contemporary casting technology.

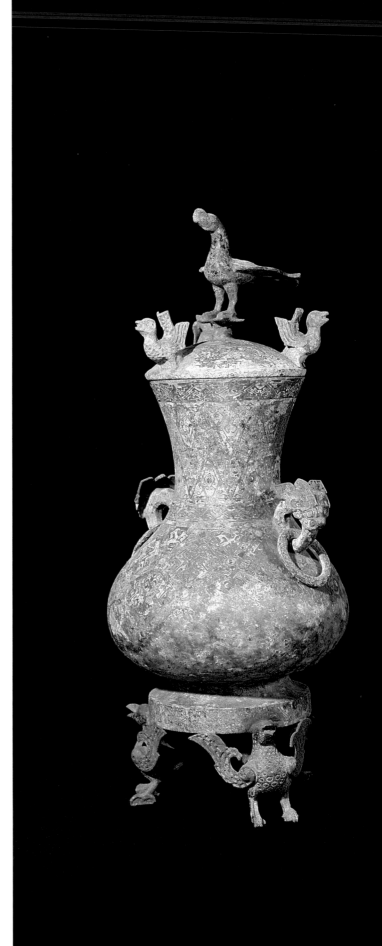

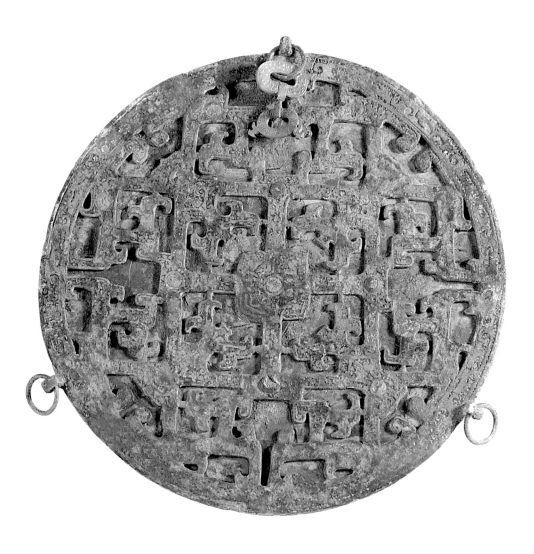

3
Bronze Mirror
Warring States period
Diameter: 29 cm
Excavated in 1965 at Sanlidun, Lianshui, Jiangsu Province

The back and the front of this round mirror were cast separately and
then joined together. Unusually, there is no handle on the back. The
back, pictured here, is decorated with open worked interlaced hydra
designs. Head to tail, these animals form an overall *jing* character design.
The central square of this pattern is further divided into four parts by the
animals' bodies. Their hook-shaped heads and tails are arranged within
these four parts. The dragons' bodies are decorated with incised line
patterns. The interlaced hydra design is embellished with silver-gilt
bubbles (the silver gilt has come off.) Three bronze rings are fixed to the
fringe of the mirror, one of which is threaded through two small oval
jade *bi*. The mirror and the whole design are original. This mirror and
the bronze deer (catalogue no. 4) were excavated from the same tomb,
leading to the supposition that the deer is the stand for the mirror.

4
Bronze Deer
Warring States period
Height: 52 cm
Excavated in 1965 at Sanlidun, Lianshui,
Jiangsu Province

This realistic model of a seated deer was mod-
elled in sections. The antlers and legs were cast
first and then joined to the body in a final cast-
ing process. The body, neck and ears of the
deer are inlaid with turquoise seeds. The body
of the animal is hollow and sandy earth
remains inside. It is possible that the deer is a
stand for the mirror (catalogue no. 3) excavat-
ed from the same tomb. The mirror would
have rested on the deer's antlers.

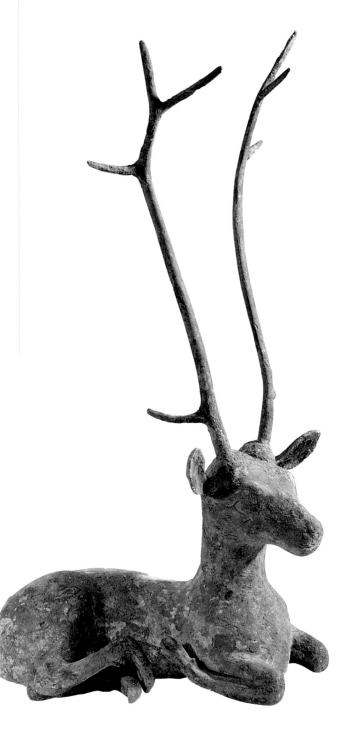

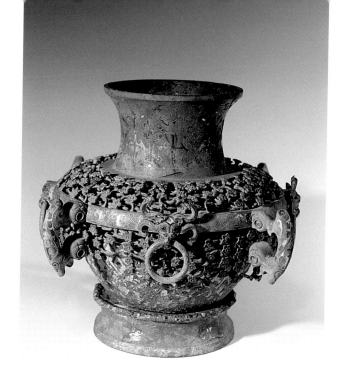

5
Gold and Silver-Inlaid Bronze *Hu* Vessel
Warring States period
Height: 24 cm
Excavated at Nanyaozhuang, Xuyi, Jiangsu Province

This bronze pot is composed of two parts: the pot itself and an outer decorative sheath. The outer sheath comprises two sets of open work three-dimensional bronze wire net sheaths which fit around the shoulder and the belly respectively. These are comprised of interlocking long dragon and plum blossom nail hooks and rings. The bronze pot is covered with gold and silver-inlaid patterns. The neck is decorated with gold-inlaid squares and cloud designs; the belly is decorated with silver-inlaid squares and cloud designs; the ring-shaped foot is decorated with gold-inlaid rhombus cloud patterns. There are inscriptions both on the inside of the mouth and the outside of the circular foot relating stories from the Warring States period of how King Kuai of Yan passed on his throne and how King Xuan of Qi attacked Yan. This bronze pot therefore combines technological, artistic and historical value.

6
Gold Animal
Western Han dynasty
Length: 17.8 cm
Excavated in 1982 from an underground storage room in Nanyaozhuang, Xuyi, Jiangsu Province

The gold animal is lying in a curled position with its head resting on the front legs and its eyes open. Its collar indicates that it is a tame animal or a pet. As its body is covered with hammered round spots it may be supposed to represent a leopard and it would have been used as a talisman. There is a handle on its back. Weighing nine kilogrammes, this is heaviest gold object ever discovered in our archaeological excavations.

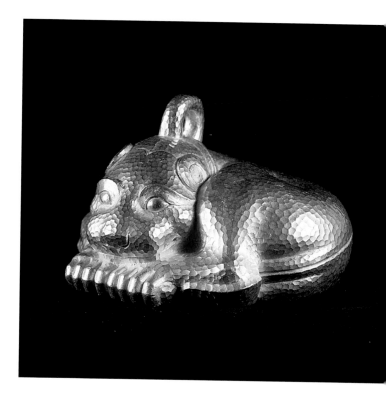

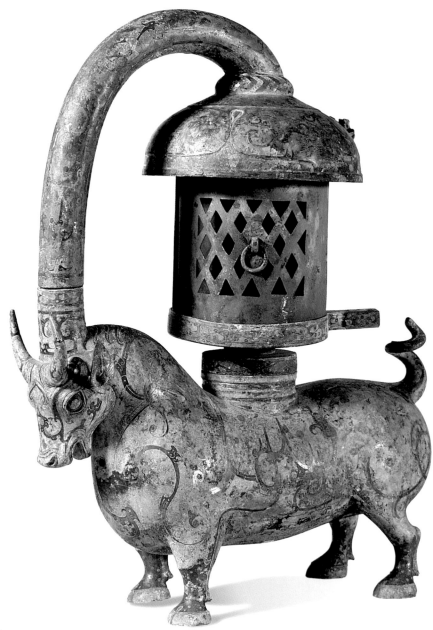

7
Bronze Ox Lamp
Early Eastern Han dynasty
Height: 46 cm
Excavated in 1980 from the No. 2 tomb at
Ganquan, Hanjiang County,
Jiangsu Province

The lamp sits on a realistically modelled standing ox base. The body of the ox is
hollow and, when the lamp was lit, the lamp black travelled through the hollow
tube joined to the top down into the water-filled body, thus making the lamp very
clean burning. There are two screens to shade the lamp, one of which has an open-
work rhomboid design. The screens are joined to the vaulted cover. The whole
lamp and stand has a base design of clouds, clouds-in-triangles and spirals cov-
ered with symbolic and mythical animals, including dragons, phoenix, tiger and
deer, all of which are inlaid with gold and silver. This is a masterpiece of model-
ling, design and technology.

8
Gilt-bronze Inkslab and Cover
Eastern Han period
25 x 10.5 cm
Excavated in 1970 from a Han dynasty tomb at Xuzhou,
Jiangsu Province.

This box, in two sections, is in the shape of an auspicious
mythical beast resembling a toad but which has horns,
wings, long teeth, and four feet, and is therefore either a
qilin or a *pixie* – both mythical animals – and certainly a
symbol of luck. The bottom section contains a smooth,
rectangular inkslab, with the protruding lower jaw of the
animal forming the water container. The base and lid of the
box are fixed with a *zimu* clasp. String could be threaded
through the ring knob on top to carry the box. The whole
box is inlaid with coral, jade and turquoise.

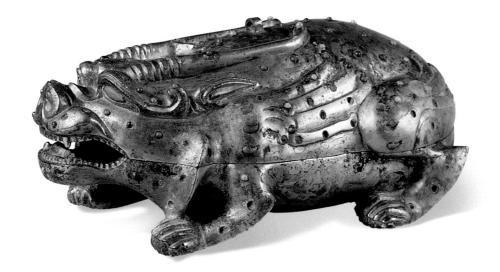

9
Bronze Lamp
Late Eastern Han – Early Three Kingdoms period
Height: 19 cm

This bronze lamp was cast in a single process. The surface bronze has become a little rusty due to long time corrosion, but the modelling is still very clear. It consists of a human figure, probably representing a diviner or magician, sitting astride the mythical creature called a *pixie*. The man wears a tall round hat with a square top, in the middle of which is a small hole for holding candles. His arms are raised, with one hand clasped around a burning candle and the other as if holding something. The animal and rider form a picture of solemnity and strength and reflect the worship of spirits and gods and the prevalence of Daoism during the late Eastern Han period.

10

Chased Gold Quatrefoil Dish
Yuan dynasty
Width: 16 cm
Excavated in 1959 from the tomb of Lu Shimeng,
Wu County, Jiangsu Province

The four sections of this quatrefoil dish are decorated
with rhomboid patterns made up of four *ruyi*-shaped
cloud patterns symbolising 'Everything you could
wish for.' Designs of various plants are engraved in
the gold: pomegranate, lotus, cherry-apple, holly,
chrysanthemum, peony and camellia. Each plant has
its own symbolic value. The chrysanthemum, for
example, symbolizes longevity and the pomegranate,
many children. A seal mark 'Made by Wen Xuan' is
cut on the bottom edge. Wen Xuan was a famous
Yuan dynasty gold and silver craftsman in the Yangzi
River area. This dish was hammered and pressed out
of a single piece of gold and, although not produced
by an imperial workshop, it is still a masterpiece of
design and craftsmanship.

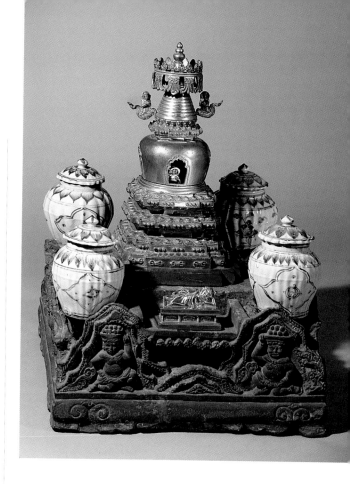

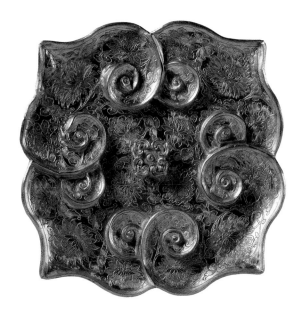

11

Gilt-bronze Stupa
Ming dynasty
Height: 32.7 cm
Discovered in 1956 in the basement of the stupa at Hongjue
Buddhist Temple, Niushoushan, Nanjing, Jiangsu Province

This stupa – a reliquary for Buddhist relics or bones of
monks – was cast with bronze in three parts: the base, the
stupa body and the monastery shrine. There are two
inscriptions on the front and back of the lower section read-
ing, respectively: 'May the Hongjue Chan (Zen) Temple of
Jinling always enjoy plentiful offerings,' and, 'Respectfully
donated by Li Fushan, a disciple of Buddha and Director of
the Directorate for Imperial Accoutrements.' This particu-
lar stupa form was introduced into China from Tibet during
the Yuan dynasty and is based on the chörten used by
Indian monks.

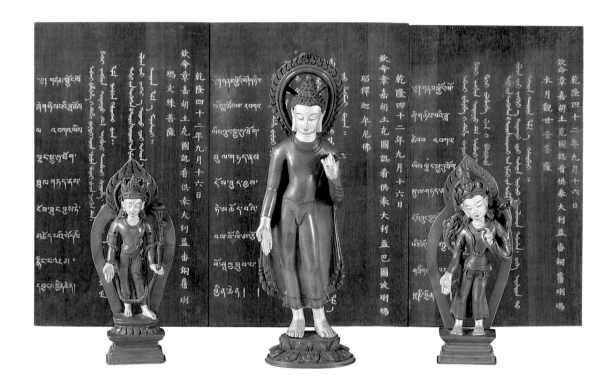

12

Gilded Bronze Buddhist Triad
Qing dynasty, Qianlong reign period
Heights :
Śākyamuni Buddha: 28.5 cm
Mañjuśrī: 18.5 cm
Avalokiteśvara: 19.1 cm

These three bronze statues represent the Buddha Śākyamuni
(centre) and the bodhisattvas Mañjuśrī (left) and
Avalokiteśvara (right) in the style of Tibetan buddhism,
which was adopted by the Manchu Qing court. The faces,
hands and feet of the statues are gilded. They were originally
contained within a wooden structure, but this has been frag-
mented and parts of it lost. The triad was presented to the
Qianlong emperor on the 16th day of the ninth month in the
42nd year of the Qianlong reign (1778) by the incarnate lama
Changjia Hutukhtu Rolpay Dorje. These details are
inscribed in inlaid gold in the Manchu, Chinese and Tibetan
languages on the extant wooden back screen.

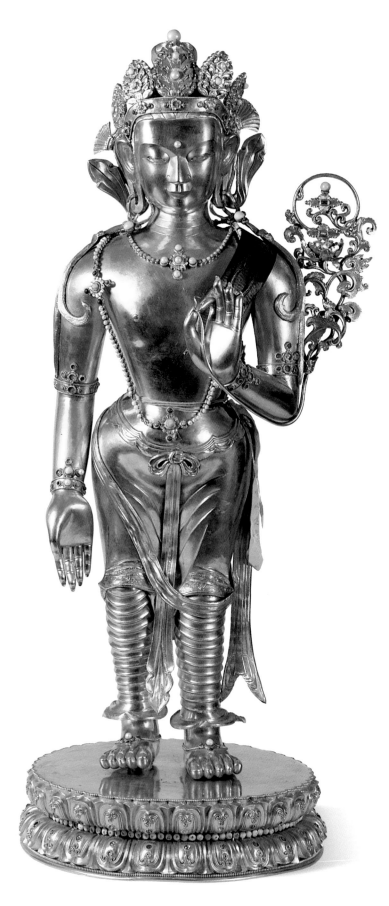

13
Gold Bodhisattva
Qing dynasty
Height: 88 cm
Made in the Imperial Palace
Workshops

Wearing a floral crown and a jade
necklace this gold bodhisattva,
Candraprabha, is in the Tibetan
style, as the Tibetan form of
tantric buddhism was patronised
by the Manchu Qing court. He is
dressed in Indian style, bare-
chested and in trousers. His left
hand is in the *adhaya mudrā* indi-
cating assurance from fear. The
right hand in the *varada mudrā*,
indicates bestowing with fingers
lightly touching the Indian lotus
that runs around his shoulders and
back.

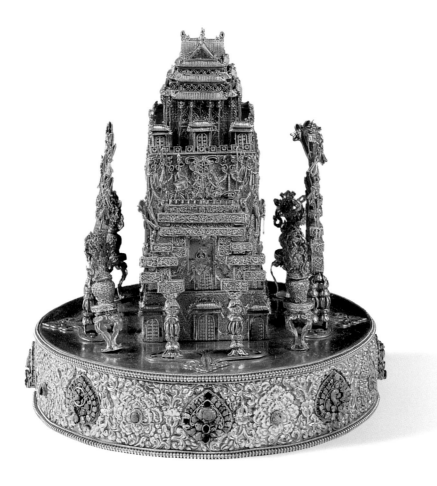

14
Gold Model Altar
Qing dynasty
Height: 20 cm

This item was made in the Imperial Goldshops. Standing out from the round
base of the object are Buddhist banners and on the outside rim are engraved
interlocking designs inlaid with turquoise. Mount Sumeru stands in the centre
with a sutra hall as its base. The doors on each side show Mahatejas – protectors
of Buddhism - and sages seated inside. Above are eight kinds of offerings shown
on all four sides. The crown is a stupa-shaped structure comprising a forest of
Buddhist banners. The shrine is a maṇḍala – a representation of the Buddhist
universe used for ritual purposes.

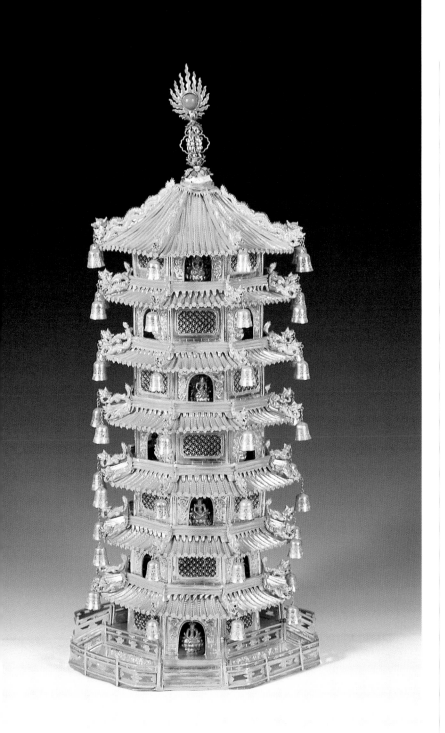

15
Gold Pagoda
Qing dynasty
Height: 43 cm

Multiple storeyed pagodas were a
feature of Buddhist architecture in
China and often contained buddhist
relics and other treasures. This model
pagoda has seven storeys, each with
four doors and a seated Buddha
inside. Decorative patterns are
carved in relief around the windows.
The roof beams are in the form of
dragons, each holding a bell in its
mouth. The pagoda spire consists of
an alms bowl in the shape of an
inverted lotus, nine wheels and a dew
bowl. The flame at the top is inlaid
with red coral representing the wish-
granting jewel or *cintāmaṇi*.

Jade is a natural stone which has been worked in China for thousands of years to make ornaments and ritual weapons and other artefacts. Its history is inextricably linked with that of Chinese culture, both dating back eight millennia, and jades continue to symbolize Chinese civilisation. Chinese jade is characterised by the numerous and complex forms — many of them for ritual use — and consummate carving techniques. China's jade artefacts occupy a distinctive place in world art.

JADE

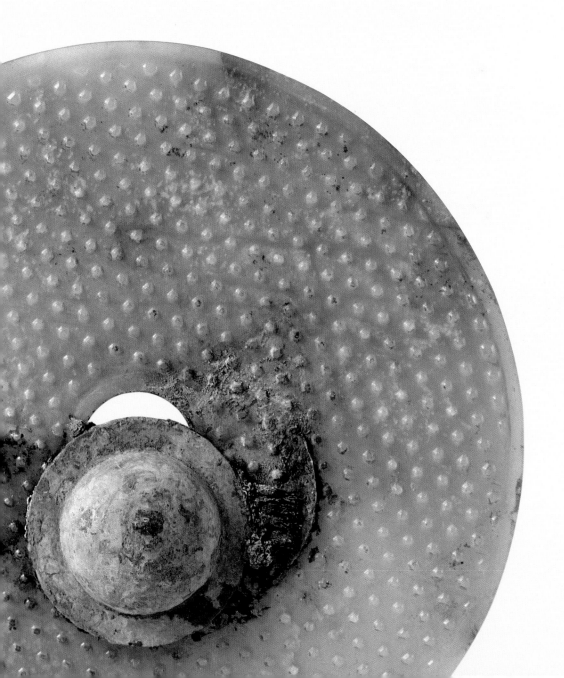

16
Jade *Cong*

Liangzhu Culture
c. 2,500 BC
Diameter: 10.2 cm
Excavated from Tomb 4 at Zhangling, Wu
County, Jiangsu Province

Cong are hollow jade objects, often with an
approximately square cross-section and a cir-
cular bore. They probably had a ritual use. This
one is made from greenish yellow jade with
original brown coloured jade skin on one side
and, on the other, earth suffusions from being
buried. It is fairly unusual in having a round
cross-section. Jade is extremely hard and
drilling a hole through the centre is a lengthy
process. The artisans would wear away the jade
using an abrasive material from both ends.
This *cong* retains some irregularity inside
where the two borings met which were not
smoothed off completely.
Four raised panels have been left on the out-
side, on each of which the same animal mask
pattern is incised. This is a splendid animal
mask circular *cong*.

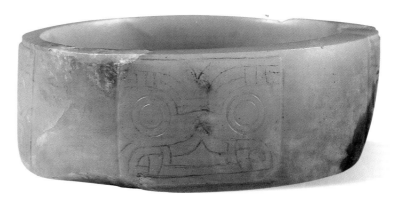

JADE

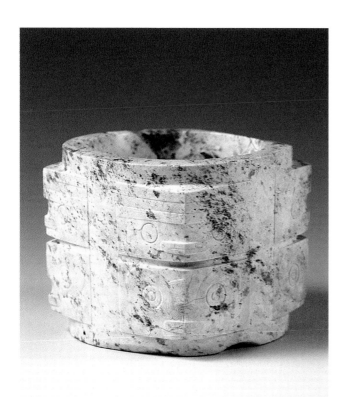

17
Jade *Cong*

Liangzhu Culture
c. 2,500 BC
Height: 7.2 cm
Excavated from Tomb No. 4 at Sidun, Wujin County,
Jiangsu Province

The cream and brown jade *cong* has a square cross-sec-
tion and circular bore. The four corners are the central
features of this *cong*, each carrying designs of a face
motif wearing a monster mask. These are depicted using
both fine shallow incising and bas relief carving. The
exquisite design and the fluent lineal patterns on this
object make it representative of Liangzhu Culture jades.

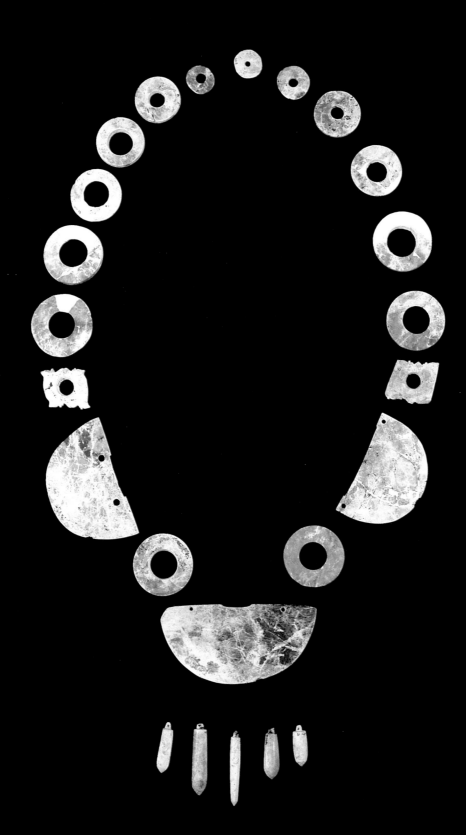

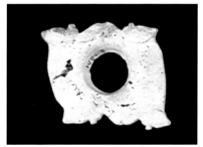

18

Jade *Pei* Pectoral

Dawenkou Culture

c. 2,500 BC

Excavated from Tomb No 60 at Huating,
Xinyi, Jiangsu Province

Pei – pierced jade plaques – were the earliest
jade ornaments in China. In the beginning
they were simple, comprising a single piece,
but soon several were strung together to
form a jade pectoral – a change indicating
both an acceleration in jade production and
social development. The spectacular pec-
toral shown here is a rare Neolithic exam-
ple. It comprises 14 jade rings of different
sizes, 2 peculiarly shaped jade *pei* with bas
relief designs of ducks in the four corners
(shown right), 3 jade *huang* (a semi-circular
flat tablet) of more or less the same shape,
and 5 jade *zhui* (drop shaped pendants) of
different lengths. Such a magnificent jade
pectoral was not designed for everyday use
and must have been a ceremonial piece dis-
playing the high rank and social status of
the wearer, a noble of the late period of
Dawenkou Culture.

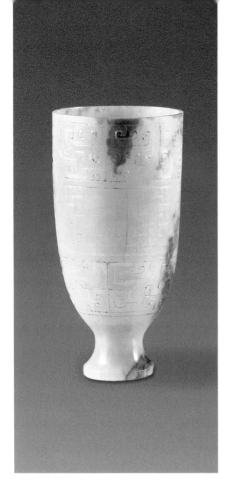

19
Jade Wine Cup
Western Han dynasty
2nd century BC
Height: 11.7 cm
Excavated from the tomb of a Chu king at Shizishan, Xuzhou, Jiangsu Province

This cup is made from a single piece of lustrous, translucent, fine and pure greenish yellow jade from Khotan (Xinjiang Province) – the primary source of jade for China. There are a few natural cracks and some suffusion of earth colour from its prolonged burial on the surface of the jade. The cup's shape reflects the style of the cultures west of China. The designs that cover the exterior surface are arranged in three tiers. Those in the upper and the lower tiers are basically the same interlaced broad cloud design, while the middle tier is decorated with a finely engraved cloud design. The three tiers are separated by bowstring patterns. This is a typical traditional Chinese design. The exterior of the cup is well polished, the interior is not: marks of its hollowing can still be seen.

20
Jade Dragon *Pei*
Western Han dynasty
2nd century BC
Length: 14.6 cm
Excavated from the Tomb of the King of Chu at Shizishan, Xuzhou, Jiangsu Province

Made of Khotan pale jade, this object is intact and as if new. If it had not been excavated, it would be hard to believe that it is a jade object sculpted two thousand years ago. The dragon is in the shape of an S. This flat *pei* seems to be a product of a pressing machine. Part of the dragon's body is decorated with an even design of sprouting grain. The exterior surface is exquisitely burnished but not the underside where vestiges of carving can be seen. This is an example of the highest quality *pei* which were owned only by the imperial family and high-ranking officials in the Han dynasty.

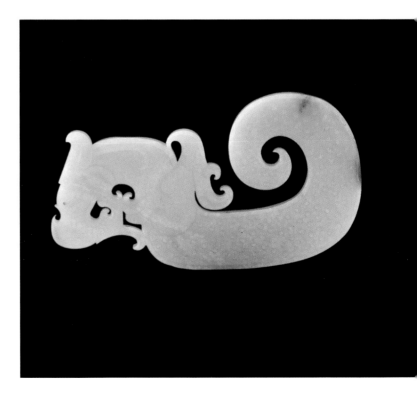

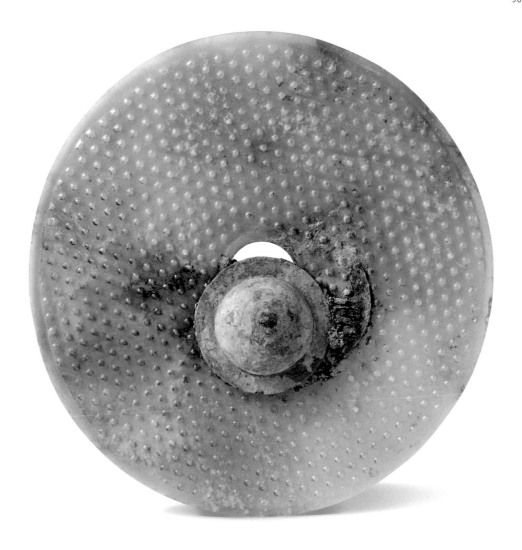

21

Jade *Bi*
Western Han dynasty
1st century BC
Diameter: 22.2cm
Found in Tomb No.2 at Gaoyoushenjushan, Jiangsu
Province

This *bi* – a flat disk with ritual functions – was found
hanging on the outside of the coffin in this tomb to pro-
tect the body within from evil spirits. Only the highest
quality jade was used for ritual and burial jades and the
carving was executed with great care. The copper nail in
the centre of this piece was used to fix the disk to the
coffin and the three streaks are marks left by silk bands
also used to hold it in place.

22
White Jade Hairpin by Lu Zigang
Ming dynasty
17th century
Length: 8.4 cm

23
Jade Calligraphic Album of 'Hong Fan' by the Imperial Brush
Qing dynasty
Qianlong reign period, 11th year (1746)
15.5 x 8.9 cm

Made of top quality green jade this album comprises eight rectangular folios. On the recto of the first folio are carved four Chinese characters 'Yu Bi Hong Fan' ('Hong Fan' by the imperial brush), with dragons – symbol of the emperor – carved on either side and a wave design below. 'Hong Fan' is an essay in the classical Chinese text, *The Book of Documents*. Zhao Mengfu, a famous Yuan dynasty calligrapher and painter, made a copy of this text. This album was made in the 11th year of the Qianlong reign period (1746), when the emperor Qianlong was practising Zhao Mengfu's style of calligraphy. The incised characters are decorated in gold paint.

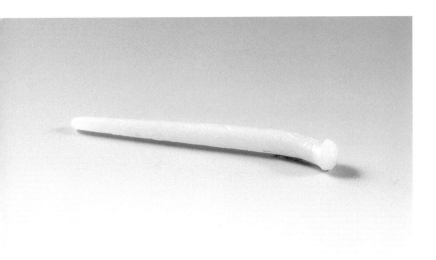

Carved from top grade pure white Khotanese jade, this lustrous and translucent jade is a typical mushroom-shaped Ming dynasty hairpin. Its distinctive feature is the faint dragon and phoenix bas relief. The three Chinese characters, 'Wen Peng Shang' (Admired by Wen Peng), are engraved on one side. Another three characters, ' Zigang zhi' (made by [Lu] Zigang), are engraved in an inconspicuous place on the bottom of the pin.

Wen Peng was Wen Zhengming's oldest son, who followed his father's career to become a famous calligrapher and painter in the late Ming. He was Lu Zigang's contemporary. Judging from the carving style of the hairpin, the inscriptions, and the historical background, we can be reasonably sure that this exquisite jade hairpin was Lu Zigang's work. This was a luxurious woman's ornament made in the Wuzhong region. A Qing dynasty document states that: 'Lu Zigang sculptured jade as if with a knife and with consummate skill. Nowadays one jade hairpin by Zigang is worth 56 taels of gold.' From this we can get an idea of the high value placed on this jade hairpin.

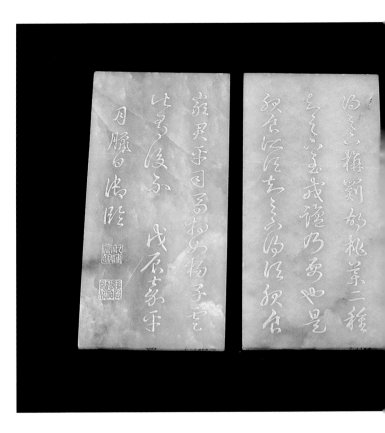

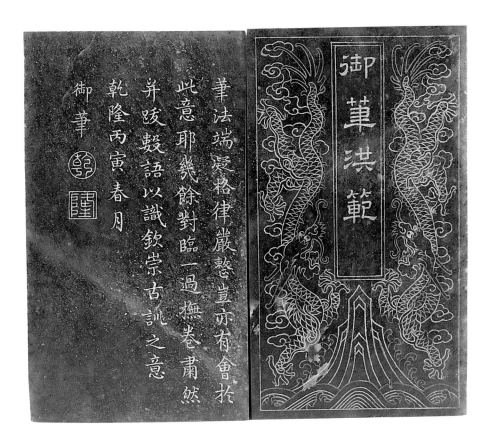

24

Jade Calligraphic Tablets 'In Imitation of Wang Xizhi by the Imperial Hand'
Qing dynasty
Qianlong reign period, 13th year (1748)
18.9 x 8.8cm

The Qianlong emperor was one of the few Chinese emperors to achieve high artistic attainments. His particular interest was Chinese calligraphy. He held Wang Xizhi in high esteem and diligently imitated Wang's 17 models of calligraphy, having them carved on jade pages such as these. The calligraphy in these pages shows untrammelled movements in writing, vigour of style and strict observance of the rules: it is remarkably true to the original. On the first page is carved the title: 'In Imitation of Wang Xizhi by the Imperial Hand'. Engraved around these characters is a design of bamboos and a pond with geese, reminiscent of famous stories from Wang Xizhi's life such as 'The Gathering at Lanting Villa' and 'Xizhi's Fondness for Geese'.

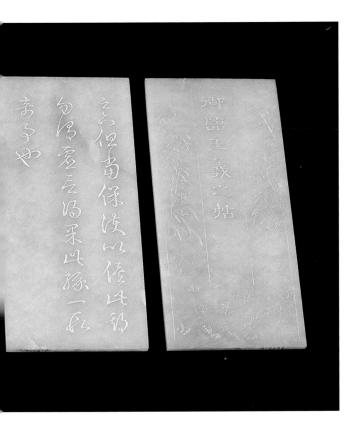

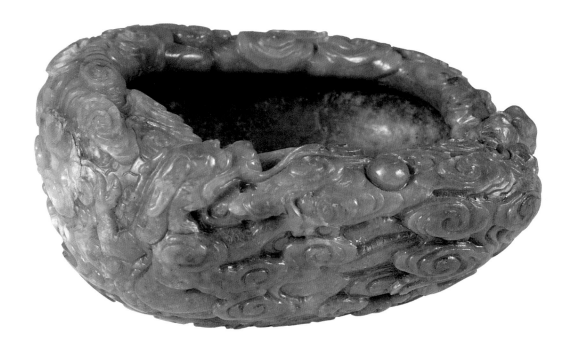

25

 Jade Brush Washer in Archaic Style
Qing dynasty
Qianlong reign period
Diameter: 19cm

Although the fashion of creating jade objects in imita-
tion of an ancient style started in the Song dynasty, it
only reached maturity in the Qing. Special features were
the importance of both form and colour, unity of deco-
ration and content, and equal stress on practical and
aesthetic qualities. This jade brush washer is modelled
out of Khotanese greenish-white jade , with the outer
part very lustrous and brightly coloured and the inner
part much paler. The outside is decorated with designs
carved in high relief showing paired dragons floating
languidly through a sea of clouds. It demonstrates the
ingenuity and consummate craftsmanship of the maker.
The Qianlong emperor was deeply impressed by this
object and composed a poem to the effect that without
seeing the jade sculptor at work one simply could not
fully appreciate his consummate art.

26
Jade Imperial Calligraphic Album
Qing dynasty
Qianlong reign period
13.2 x 10.5 cm

'The Seven-Buddha Pagoda Inscription' was written by the Qianlong emperor
and copied by the vice minister of the Ministry of Civil Personnel, Xie Yong.
It was engraved on top quality green jade to make a jade album. The so-called
seven Buddhas were actually only one. The seven Buddha *gatha*, an outline of
the doctrine of Chan (Zen) Buddhism, is found in several, not just one,
Buddhist sutra. Engraved on the cover of the album is a seven storey pagoda
flanked by dragons. 'Seven-Buddha Pagoda Inscription' is engraved in seal
script on the title page and inlaid with gold. The full text of the inscription in
seal script is also inscribed with inlaid gold on a glazed ground on the verso.
This album is exquisitely made and luxuriously bound.

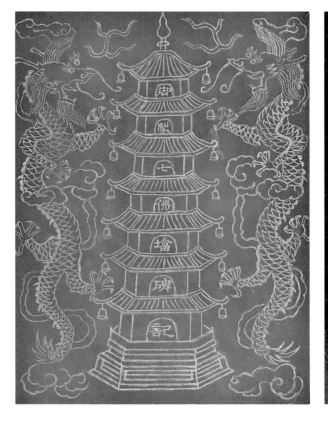

27
Jade *Ruyi* Sceptre
Qing dynasty
18th century
Length: 41.5 cm

Ruyi is a double curved sceptre shaped like a sacred fungus
and having the symbolic meaning: 'Everything you wish'.
Jade *ruyi* were particularly treasured by the Manchus and, as
the Qing emperors were Manchu, jade *ruyi* became a symbol
of the peace and prosperity of the empire. This example is
made of top quality Khotanese pale jade. The long curved
handle and the drifting cloud-shaped head with the designs
of bats (prosperity), *qing* (a musical instrument made of jade
or stone) and *fangsheng* (a lozenge-shaped symbol of victory)
together create an auspicious scene of all the happiness and
longevity one could wish for.

28
Three Jade Animals
Qing dynasty
18th century
Lengths: 9-11cm

Jade animal sculpture in the Qing dynasty developed considerably, building on the knowledge and skill of past generations. Ever better quality jade was used, the modelling grew livelier, and craftsmanship became even more exquisite. Jade animals are among the most charming artistic jade objects of the time. The three shown here were carved from top quality Khotanese jade. Each has a different demeanour, but whether squatting or walking, they are full of wit and humour.

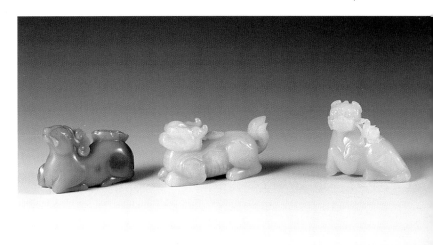

29
Jadeite Court Beads
Qing dynasty
18th century
From the tomb of Bi Yuan, Lingyan, Wu County, Jiangsu Province

Court beads were unique ornaments worn by Qing dynasty officials and nobility and there were strict regulations concerning their material, colour and use. According to these: 'The emperor's court beads are of various types. His majesty should, however, only wear lapis lazuli when performing duties at the Temple of Heaven, amber at the Temple of Earth, coral at the Temple of the Sun, and turquoise at the Temple of the Moon.' Officials under the emperor wore more precious and more colourful court beads. This set of jadeite court beads worn by Bi Yuan – a successful candidate in the national examination held in the imperial capital under the Qianlong emperor — is the most magnificent of its kind found to date. It comprises 108 jadeite beads and 4 pink tourmaline Buddha heads. Guangzhou (Canton) was the chief trading centre for Burmese jadeite during the Qing dynasty. Bi Yuan had once served as the governor there and, capitalising on his location and official position, as well as his considerable knowledge of jadeite, he was able to purchase the best stone and have it made into the beads that he wore when he went to the imperial court.

Chinese tradition demanded that the dead be served as if they were still alive, and pottery goods made to bury with the dead were sometimes more exquisite than those made for the living. Funerary pottery objects therefore represent the peak of ceramic skills. Neolithic pottery pigs, the Southern Dynasties' 'Seven Sages of the Bamboo Grove' (now listed as a National Treasure), the graceful female dancer, or the pottery figurine guards with shields, are all masterpieces of their time in the Nanjing Museum collection. Just as the invention of pottery testifies to the progress of human civilization, so does the invention of porcelain to the innovativeness of Chinese culture. Although it took over one thousand years for the earthenware of the Shang and Zhou dynasties to develop into the refined Eastern Han green wares, after that progress was fast. The Ming and the Qing families established kilns and their porcelain wares became famous both at home and abroad. Among them, those reserved for the exclusive use of the Chinese emperors were considered as beyond comparison.

CERAMICS

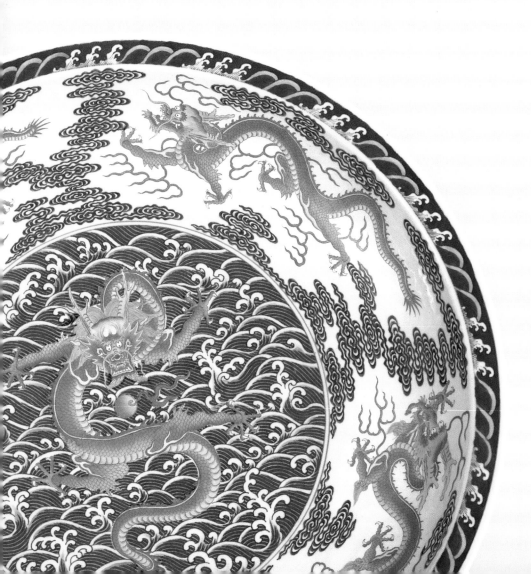

CERAMICS

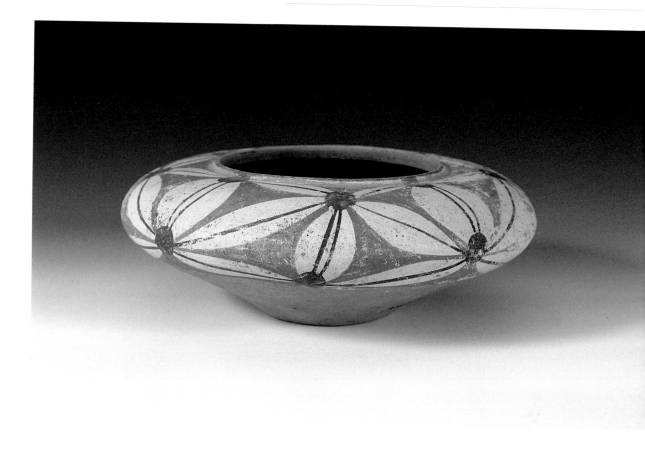

30
Neolithic Pottery Pot
Dawenkou Culture
4500–3000 BC
Height: 9.6 cm
Excavated in 1976 at Dadunzi, Pi County, Jiangsu Province

This wheel turned pot is made of red fine clay. It is decorated with
a linked design in white, reddish brown and brown.

Southern Green Glazed Pot With Mythical Animal Design

Southern dynasties, Western Jin
Height: 27.9 cm
Excavated in 1976 in Zhou's burial mound, Yixing, Jiangsu Province

On the interior surface of this celadon pot there are clear traces of the spinning pattern left from the wheel. The modelling is unusual, but retains characteristics of its time. The animal modelled on the body of the pot is clearly not a depiction of any actual creature. It has protruding eyes, large ears, holds a pearl on its protruding tongue and has a long beard and a bearded chin. It has five dorsal fin-shaped tails on its back. It may be considered to be a talisman – a protector against evil.

There are two horizontal lug handles on either side of the upper shoulder of the pot and two smaller lugs in the middle section. Both the inside and outside are glazed in green. Half of the exterior surface is suffused with a yellowish colour embellished with small crackles. Comb patterns and stamped designs of varying thickness are found on parts of the exterior surface. The foot is unevenly glazed and areas of brown are exposed where there is no glaze. Nine firing scars can be seen on the rim of the foot. The two characters 'Dong Zhou' (Eastern Province) are inscribed on the base. According to research the owner of the tomb where this pot was unearthed was a famous figure of the Western Jin Dynasty named Zhou Chu.

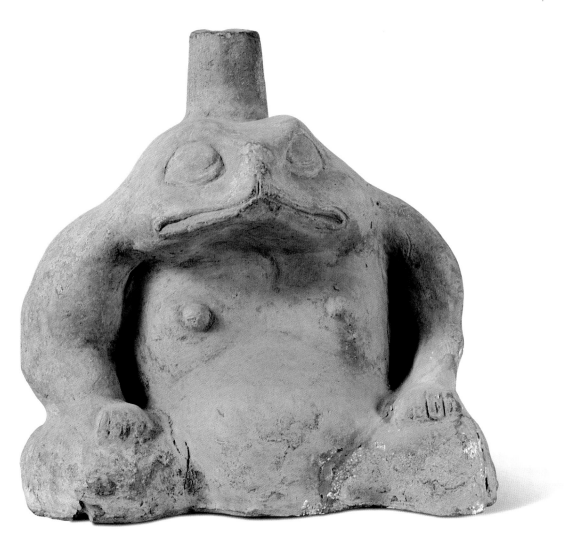

32
Red Pottery Pole Stand
Eastern Han dynasty
Height: 39.5 cm
Excaved in 1942 at Pengshan, Sichuan Province

This large squatting toad with human form has
been modelled in grey clay. Objects could be placed
into the hollow cylinder on the crown of its head. It
is the only Han Dynasty pottery object with this form
found in the whole of China. This toad-head stand
is both lively and imposing, fully demonstrating
the refined sculptural art of the Han dynasty.

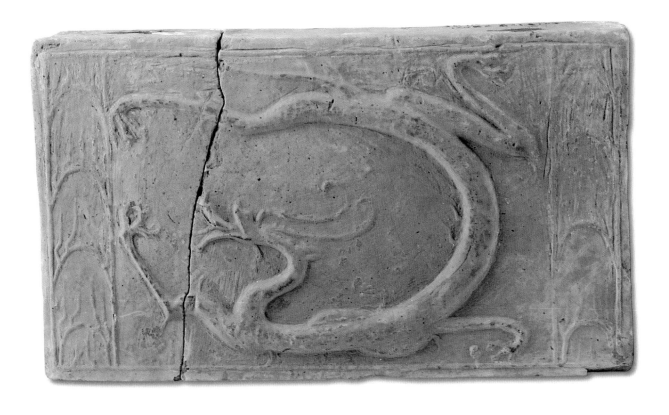

CERAMICS

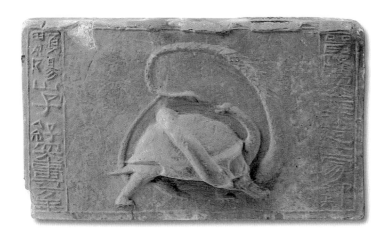

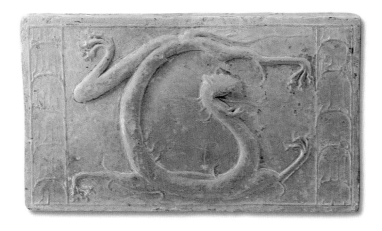

33

Moulded Grey Pottery Bricks with Animals of the Four Directions

Southern dynasties, Eastern Jin

Longan reign period, 2nd year (398)

31.5 x 18 x 4.5 cm

Discovered in 1972 at a farm on the outskirts of Zhenjiang

Four colours and animals are found in Chinese mythology and iconography to represent the four cardinal points. They are the black tortoise, white tiger, blue dragon and red bird, for north, south, east and west respectively. Here the animals are engraved in bold relief on the four bricks.

The tortoise brick has an inscription on either side of the image reading 'This tomb was built in the second year of the Longan reign period, [Eastern] Jin dynasty and inscribed by Yongshan descendents for longevity of ten thousand years.' This brick therefore provides a time reference for studying the development of the art of decoration in the Southern dynasties.

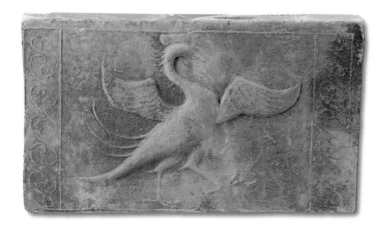

CERAMICS

34
Grey Pottery Brick with Design of a Winged Immortal Sporting with a Dragon
Southern dynasties
90 x 340 cm
Excavated in 1968 at Huqiao Baoshan, Danyang, Jiangsu Province

The line drawing impressed onto this grey pottery moulded brick is an important source for the study of Southern dynasties' art. The winged immortal stands on one side with a long floating band at his waist and in a long jacket with wide sleeves . One hand holds magical herbs and the other a long-handled ladle filled with fire. The dragon dances across the rest of the brick, with three heavenly beings flying above, their clothes floating behind them. They are especially clearly delineated, full of grace and charm.

35
Grey Pottery Brick with Design of a Winged Immortal Sporting with a Tiger

Southern dynasties

90 x 345 cm

Excavated in 1968 at Jianshan Jinwangcun, Danyang, Jiangsu Province

An intaglio inscription on one side of this grey pottery moulded brick starts with the characters, 'Great Tiger…' The winged immortal wears a long flowing band around his waist and carries a Daoist fly-brush in one hand. The dancing tiger with bared teeth occupies the centre of the picture. In the upper right hand corner are celestial beings, one of them is holding fruit, another is distributing it. The whole picture presents a scene where everything appears to be floating in the breeze: the rolling clouds, swaying flowers and grass, the long clothes and bands fluttering like silk threads.

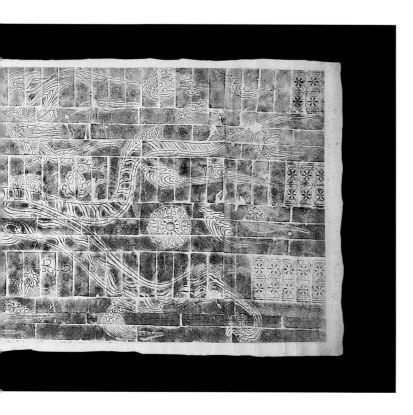

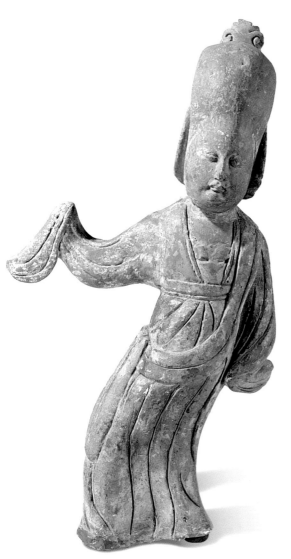

CERAMICS

36
Grey Pottery Female Dancer
Southern Tang dynasty
46.5 cm
Excavated in 1950 at Zutangshan, Nanjing

This elegant female dancer has been modelled
with great skill. She wears her hair on top of
her head, and her dancing costume consists of
a floor-length gown with long sleeves, a cape
and shoes with turned-up toes, all fashionable
dress of the time. The broad movements of
this dancer figure represent a popular Tang
dynasty style of dance and its finding has pro-
vided important information on contempo-
rary music and dance.

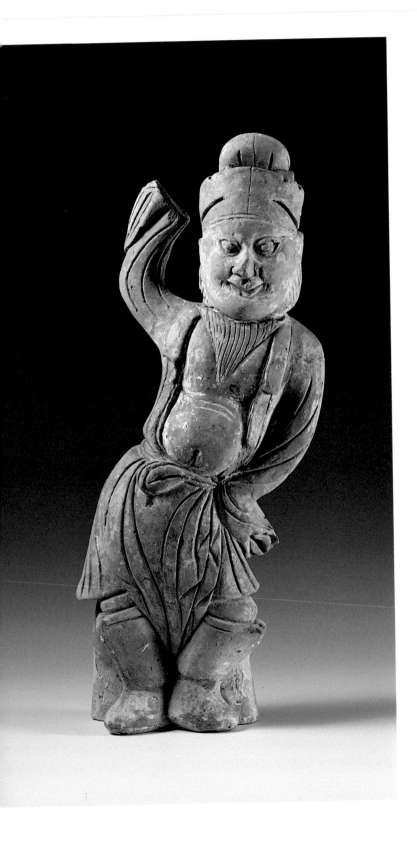

37
Grey Pottery Tomb Figure of Male Dancer
Southern Tang dynasty
46 cm
Excavated in 1950 at Zutangshan, Nanjing

The Tang imperial court had in residence
many foreign dancers, musicians and
entertainers, and this figure represents one of
them. He is clearly non-Chinese, with deep-set
eyes, a large nose and a beard. His hat, gown
and boots are also the dress of non-Chinese,
although the short gown became popular in the
Tang among both Chinese men and women.

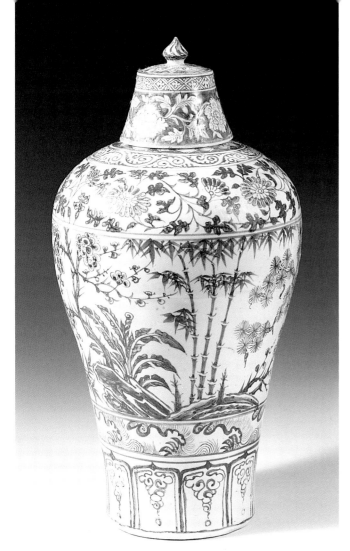

38

Underglaze Copper Red *Meiping*

Ming dynasty, Hongwu reign period

Height: 36.8 cm

Excavated in 1957 from Song Hu's Tomb, Sunjiashan,
Dongshanqiaozhen, Jiangning, Jiangsu Province

Meiping – literally, plum blossom vase – is a form first
seen in the Song dynasty with a wide shoulder and nar-
row mouth. This vase is made of pure white porcelain
and is rare because it still has its lid or cover. The cover
is bell-shaped with a jewel hold and a tube inside.
Underglaze copper red wares are most common in the
late fourteenth century when they outnumber the blue
and white glazes. However, the firing of the colour is
often not very successful, probably as a result of failure
to fire at a high enough temperature, poor reduction or
too thin a glaze. Here the colour is greenish. The interior
of this vase is thinly and unevenly glazed.

There are several decorative registers. The cover top is
decorated with white chrysanthemums and a *ruyi*-
shaped lotus design on a dark ground. There is a geo-
metrically-patterned brim around the top and a design
of white interlocking peonies on a dark ground below.
The neck of the vase itself is decorated with two circles of
double-stem plantain leaf designs and the shoulder is
adorned with three tiers of decorations: *ruyi*-shaped
white flowers on red ground, curly grass blades, and
interlocking chrysanthemums. The theme design of 'the
three friends in cold weather" is painted on the body in
the widest register. These are the traditional designs
used by men of letters of the Yuan dynasty. Pines,
bamboo and plums are three plants that withstand
cold and are employed as decorations to represent
enduring friendship through adversity. To achieve
symmetrical beauty, a plantain is added to the picture
against a background of mountain rocks, flowers, and
grass. A design of *ruyi*-shaped lotus petals is painted
on the foot. The base is gritty with grains of sand still
stuck to it from the kiln.

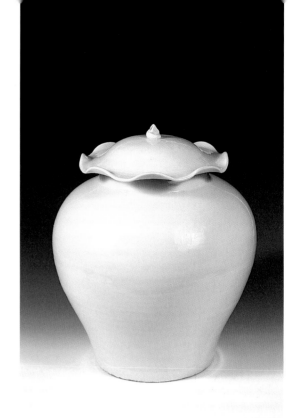

39
White Glazed Jar with Lotus Leaf Shaped Cover
Ming dynasty, Hongwu reign period
Height: 40 cm

White glazes had been perfected in the later Yuan dynasty and often showed a blueish or greenish tinge, as here. The cover of this jar is shaped like a lotus leaf with a peduncular hold in the middle. A leafstalk pattern is engraved on the cover and the flared cover brim is modelled in a modulating manner. The interior of the jar is also white glazed. The base is gritty.

40
White Glazed *Meiping* with Inscription
Ming dynasty, Hongwu reign period
Height: 40 cm
Excavated from Shejitan, Nanjing.

This object was excavated from a large well in Shejitan, which lies to the east of the ruins of an old early Ming palace in Nanjing. It was 11 metres down in the silt along with white porcelain *jue* and bowls. The inscription on the vase reads 'Bestowed' and research has found that this was a reward granted to an official by Emperor Zhu Yuanzhang, the founder of the Ming dynasty. It is probably a wine bottle. Its recipient is not known, nor the reason why it was buried in the bottom of the well, and this adds to its mystery. The modelling of this porcelain vase demonstrates the inheritance of the elegant style of the Yuan dynasty *meiping*: flared brim, slender neck, wide round shoulders, and a slight concavity in the long body as it tapers to the foot. There are traces of spinning patterns from the wheel. Research also shows it was produced in the years shortly before or after Zhu Yuanzhang established his empire in 1368 – he had taken Nanjing as early as 1356. This porcelain *meiping* is the only one of its kind ever found.

CERAMICS

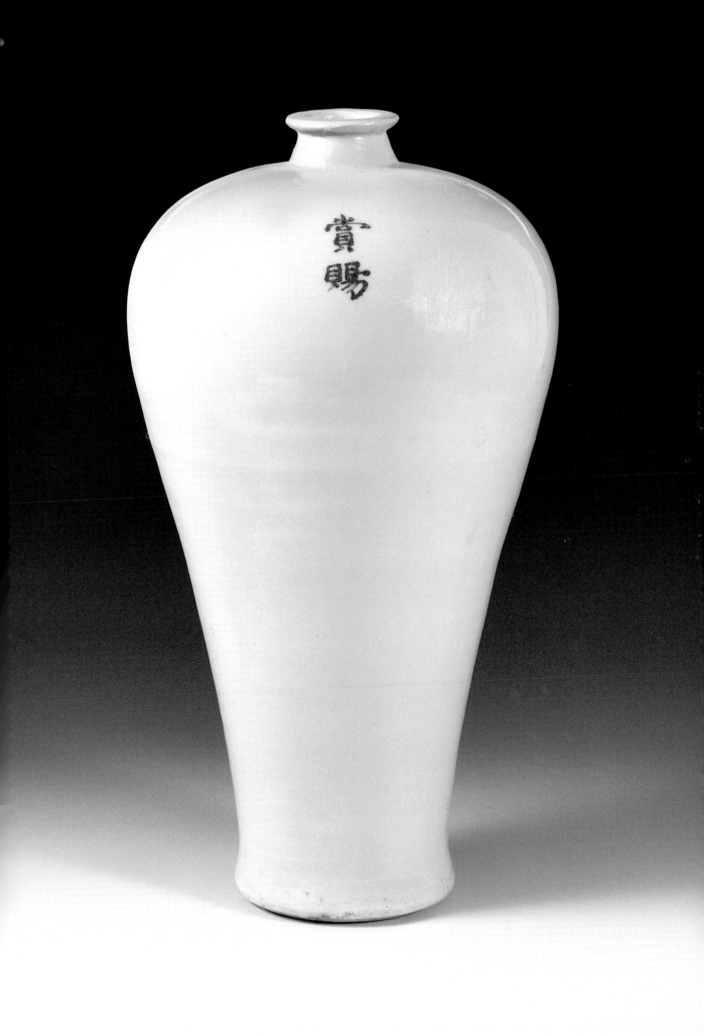

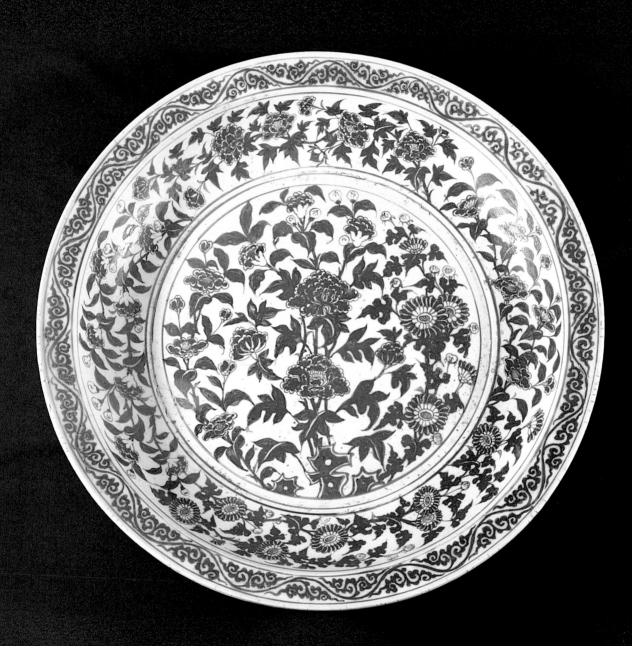

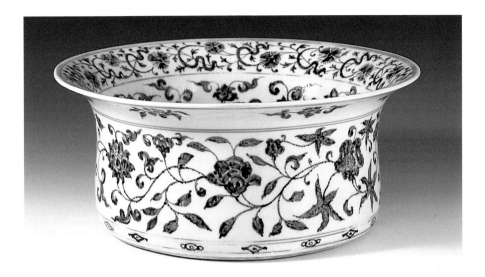

41

Underglaze Copper Red Plate with Flower Design

Ming dynasty, Hongwu reign period
Diameter: 57.3 cm

This plate is thick and heavy. The large circular
foot has been brushed with lilac slip which has
given it a reddish colour. The white glaze is suf-
fused with blue. The underglaze red is bright, but
shows a little halo-spread of colour due to the
excessive temperature used in the processing.
The interior surface is decorated with three bands
of designs; the flared outer brim is decorated with
white flower and cursive sketches on a red
ground; the inner rim has peony and chrysanthe-
mum designs; and in the centre of the plate is
painted a design of rocks and peony with stems.
The underneath is decorated with the same
designs as those on the inner rim.

42

Blue and White Brush Washer with Floral Design

Ming dynasty, Yongle reign period
Height: 13.5 cm

This brush washer is relatively thin and light with a white glaze
suffused with green and a deep and dense underglaze blue showing
black iron flecks (produced because of the high iron content of the
glaze). There are several registers of floral designs on both the inside
and outside including: interlocking carnations; interlocking lotus;
thunder patterns; wheel designs; lotuses with treasures — such as
pearls and rhinoceros' horns — depicted inside the petals and *ruyi*
crosses at their hearts; eight flowers; interlocking floral patterns of
convolvulus, peony, chrysanthemum, hibiscus and camellia; and six-
teen flowers. The different registers are separated with string pat-
terns. The pot has a fine, smooth, flat, unglazed bottom with circle of
pottery red showing where the glaze meets the unpolished bottom.
There are only about ten such intact washers of this kind made in the
Yongle reign period, one such being in the MOA Museum in Japan.

CERAMICS

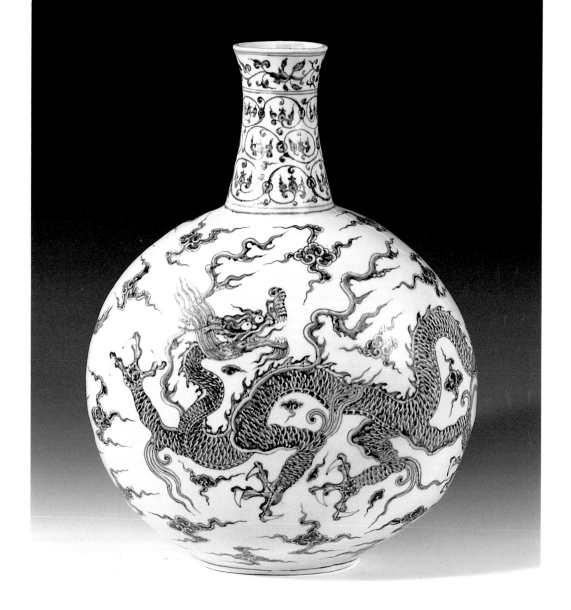

43
Blue and White Floral *Bianping* Flask
Ming dynasty, Yongle reign period
Height: 45.8 cm

This is a solidly built flask, both thick and heavy. The long cylindrical neck is slightly attenuated in the middle section. The lower part of the big flat belly gradually narrows down to the short elliptically shaped foot. The whole vessel is densely glazed both inside and outside except on the base of the elliptical foot which shows the colour of fired kaolin. The white glaze is suffused with green and the flask is covered with decorative designs in underglaze blue, showing some black iron flecks. The mouth brim is adorned with interlocking decorative bands of plum blossom and convolvulus; the neck has three registers of interlocking pomegranate patterns; and there is a dragon surrounded with cruciform-shaped clouds on either side of the flat belly. The designs are executed with vigorous strokes.

44
Blue and White Tripod *Ding*
Ming dynasty, Xuande reign period
Height: 58 cm

This large, thick ceramic *ding* – tripod – was made
in imitation of ancient bronze vessels. The interi-
or is glazed white and the exterior, even the feet
and handles, is covered with a mountain and sea
design in underglaze blue, representing longevity
(the mountains) and good fortune (the sea).
Some black iron flecks can be seen in the under-
glaze. Intact longevity and good fortune *ding* of
the Xuande reign period are exceptionally rare.

CERAMICS

45
Blue and White Dragon Bowl
Ming dynasty, Xuande reign period
Height: 12.5 cm

Both the inside and outside of this
thick and solid bowl are white glazed.
The inscription mark 'made in the
Xuande reign period of the great
Ming dynasty' in regular script is
painted inside a double circle on the
inside bottom (pictured right). The
exterior surface is decorated with
three registers in underglaze blue,
showing some flecks of iron. The top
register carries a wave design. Below
this are two dragons moving among
cruciform-shaped clouds, and the
bottom register is of lotus petal pat-
terns. The small flat bottom is
unglazed but smooth.

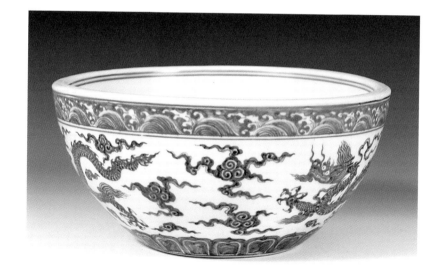

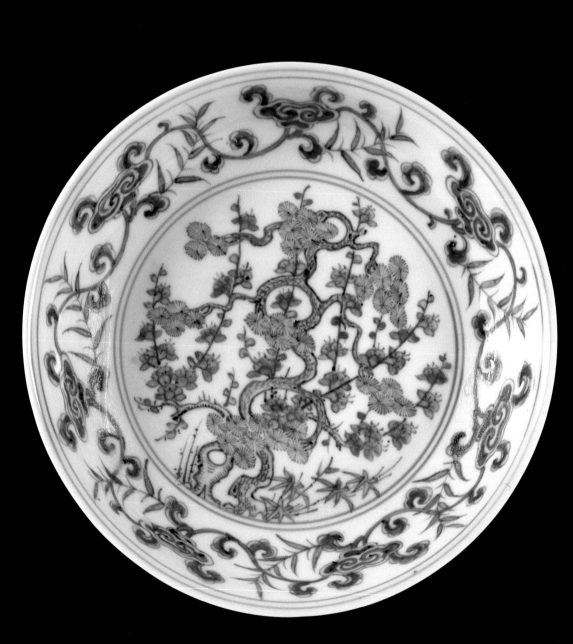

47
Gold Decorated Yellow Glazed Jar
Ming dynasty, Hongzhi reign period
Height: 31 cm

This solid, but quite fine, jar is glazed on the inside in white and with
yellow on the exterior. The colours are light, even, and lustrous.
It originally had gold string patterns along the brim, but most of these
have been worn off. It has two ear handles and a gritty base. Traces of
spinning marks from the wheel-throwing process can be faintly seen on
both the inside and outside. Yellow glazed porcelain wares produced
in the Hongzhi reign period were the finest of Ming and Qing imperial
wares. The glaze is sometimes called 'chicken fat yellow' because of
the delicate colour or '*jiao* – delicate yellow' because of the glazing
technique.

46

**Blue and White Dish with 'Three Friends of Winter'
Design**
Ming dynasty, Chenghua reign period
Height: 4.8 cm Diameter: 21.7 cm

By the Chenghua reign period of the Ming
dynasty, the jade-like smoothness and glossiness
of the white glaze and the refined elegance of the
colour characterised blue and white porcelains.
This plate displays just these qualities. Though
there is no mark indicating its maker, the story of
its transmission and its superb quality suggest
that it was the product of an imperial kiln. The
central portion and the underside of the plate
show pine trees, bamboo and plum, a decorative
pattern called 'the three winter friends'. The
design around the rim is of sacred mushrooms
and bamboo leaves, also emblems of longevity.

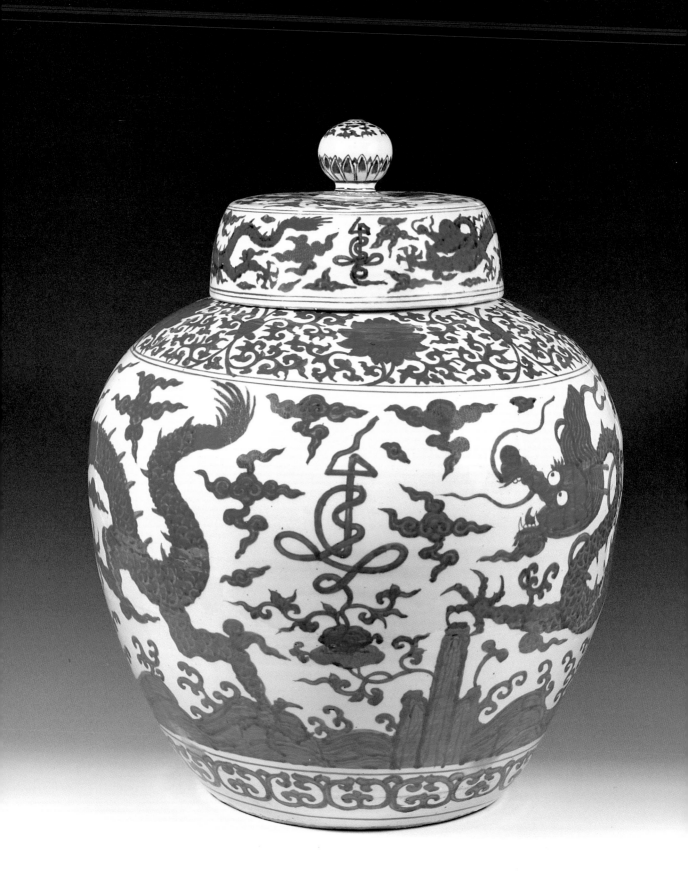

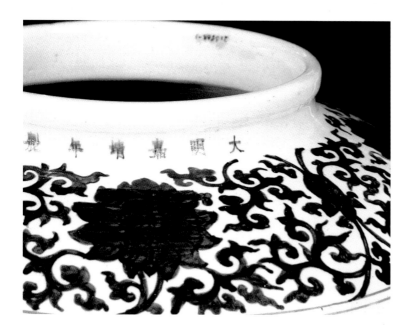

CERAMICS

48
Blue and White Dragon Jar with Cover
Ming dynasty, Jiaqing reign period
Height: 67.5 cm

Underglaze blue wares, such as this, are characteristic of imperial porcelains made in the Jiaqing reign period of the Ming dynasty. The jar shown here has a blue glazed inscription on its shoulder and one in seal form on the base, both dating it to this reign period. The jar is solid and heavy, and white glaze is suffused with green. The base is gritty and rough. The main design shows dragons among clouds and is found both on the cover and the main body of the pot itself. Between the two dragons is a design of a lotus with its stem forming the character *shou* (longevity). The mountain and sea design below represents longevity and good fortune.

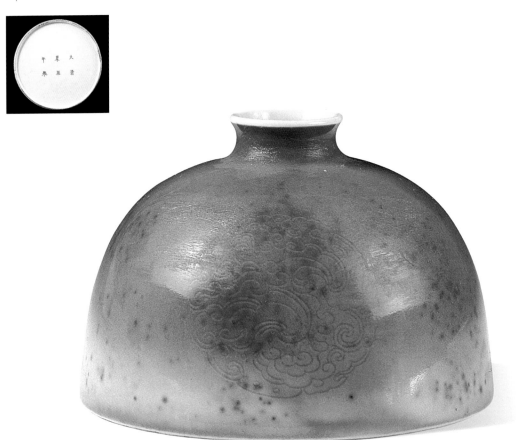

49
Peach Bloom Water Pot with Incised Dragon Designs
Qing dynasty, Kangxi reign period
Height: 8.7 cm

This water pot, also known as 'Taibaizun', has a circular foot with a shallow convex rim. The inside and bottom are both glazed white while the outside has a kidney bean red glaze showing green mossy specks typical of this copper red underglaze also known as 'peach bloom glaze'. Three symmetrical dragons are incised on the top part of the pot. At the bottom is the mark, 'made under Kangxi reign period of the great Qing dynasty', inscribed in regular script of six characters in three lines (pictured above).

50
Blue and White Fish-dragon Bowl
Qing dynasty, Kangxi reign period
Height: 7.6 cm

This fine, delicate bowl is glazed white with an underglazed blue design in the centre. This shows a dragon and fish swimming among waves and represents an ancient legend about the metamorphosis of a fish into a dragon. The dragon takes a dominant position in the picture. The flat bottom is also glazed. Six characters in regular script 'made in the Kangxi reign period of the great Qing dynasty' are inscribed in the blue glaze within a double circle on the base (pictured right), but the calligraphy is careless, suggesting that this bowl was made in the early years of the Kangxi reign period.

CERAMICS

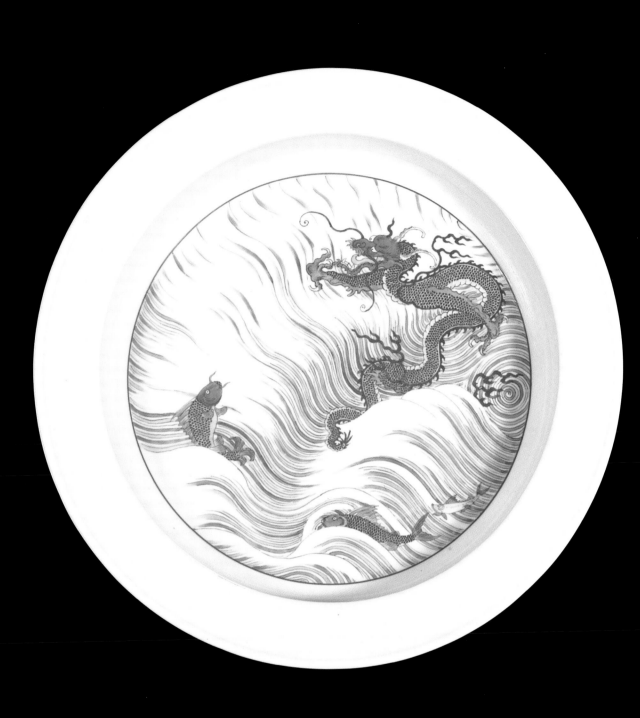

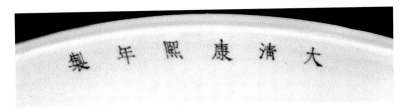

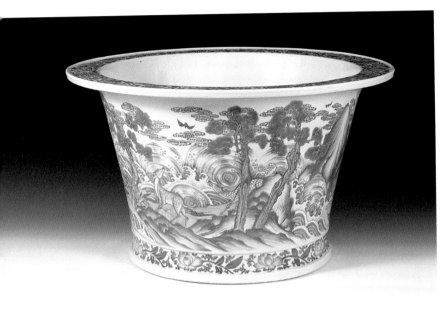

51
Large Blue and White Flower Pot
Qing dynasty, Kangxi reign period
Height: 36 cm

This is a large, thick pot with a round hole in the bottom. The white glaze on both the inside and outside of the pot is smooth and lustrous. The flared rim is adorned with peach tree patterns. The decorations on the body are like a scroll painting presenting a spectacular landscape of rolling waves, precipitous mountain rocks and sturdy green pines with bats fluttering in the air and deer on the ground, all symbols of longevity, good fortune and happiness. The lotus flowers on the stem are painted clearly and accurately in the blue underglaze. This flower pot is, in its own right, an object for appreciation and enjoyment. The line of six characters in regular script under the flared rim reads, 'made in the Kangxi reign period of the great Qing dynasty' (shown above).

52
Blue and White *Zun* Vase
Qing dynasty, Kangxi reign period
Height: 77 cm

From marks on the interior it can be seen that this large and heavy *zun* consists of three separately prefabricated sections: that from the shoulder up; the central part; and the lower section. The excellent workmanship in joining the sections left no trace of the joins on the outside. The character for longevity – *shou* – is painted all over the vessel in underglaze blue. There are two circles of 77 characters each on the flat surface of the rim and 48 along its exterior rim. The characters on the neck and the body are neatly arranged in 758 columns, each containing 130 characters. A further 48 adorn the foot rim, making a total of almost 10,0000. The character is written in a wide variety of forms based on the six major different calligraphic styles such as large seal, small seal and regular script.

53
Doucai **Decorated Flower Pot**
Qing dynasty, Kangxi reign period
Height: 32 cm

This hexagonal pot is thick and heavy with feet in four of the corners and two holes in the bottom. The white glazed exterior has a greenish tinge and a waves design. The interior is half glazed. The enamel paintings are in contrasting colours – *doucai*. The rim is adorned with flower designs with the character for longevity – *shou* – painted in a round form in four circular gaps left in the design. The six sides of the pot are all decorated with designs of immortals. On each of the two large sides are painted Daoist monks with toads and bats representing harmony and unity, the immortal Liu Hai (a famous 10th century statesman and Daoist) riding his three-legged toad, and the plum blossom of five blessings (represented by the five petalled-flowers). On each of the four smaller sides are paintings of a Daoist monk, bats, red-crowned cranes, longevity peaches, and sacred fungus, all symbols of longevity, wealth and high position, so together presenting scenes of propitious omen. Six characters have been incised and then painted under the rim, reading: 'Made in the Kangxi reign period of the great Qing dynasty' (pictured left).

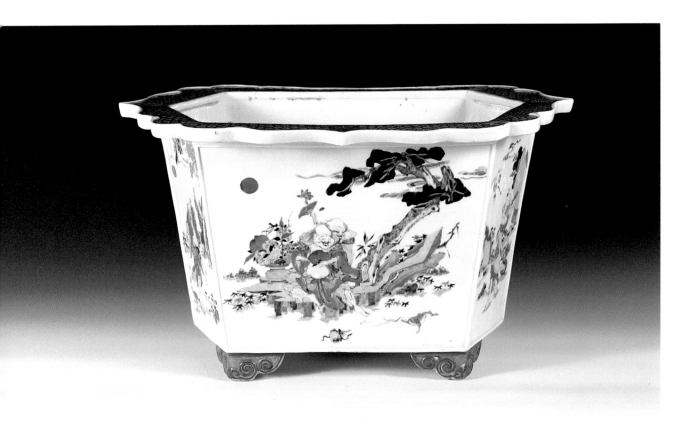

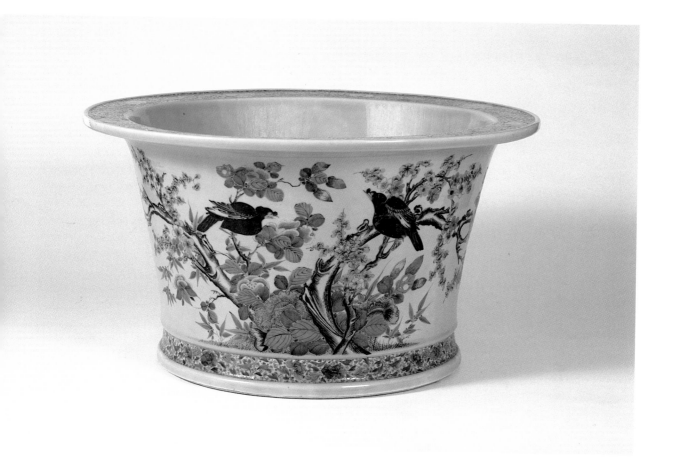

54

Underglaze Green *Wucai* Decorated Flower Pot
Qing dynasty
Kangxi reign period
Height: 33.5 cm

This thick and heavy pot has a shallow circular foot and a hole in its bottom. The base is gritty. The outside in underglazed bean-green serves as the background for the polychrome pictures. The rim and stem are decorated with a peony and sacred fungus design with the character for longevity – *shou* – painted in a round form in four gaps left in the design. Two mynah birds with shiny black feathers are painted on the body of the pot, one on a Chinese rose and the other on a plum tree. The plum branches encircle the pot completely. Six characters in regular script have been written in blue glaze under the rim, reading: 'Made in the Kangxi reign period of the great Qing dynasty'.

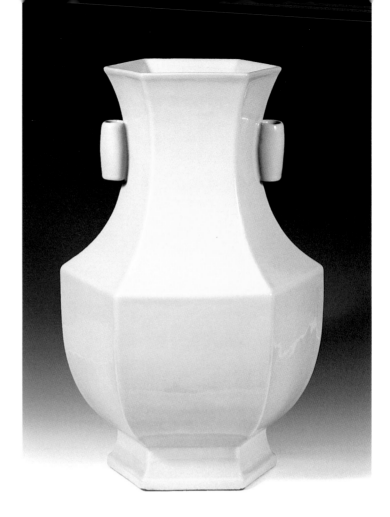

55
Hexagonal *Ru*-type Glaze *Zun* Vase
Qing dynasty, Yongzheng reign period
Height: 63.5 cm

This vessel's modelling and colour emulate ancient examples. Lug handles
were placed on vessels for practical purposes from as early as the Neolithic
Liangzhu Culture period, that is, four thousand years ago. In the Song
dynasty, porcelain vessels with such lugs were common. The hexagonal
form was developed from porcelains of the Wanli and Jiaqing reign periods
in the preceding Ming dynasty, but the overall structure of this *zun* echoes
much earlier bronzes. The clear and lustrous and greenish-grey glaze
colour is characteristic of imitation Song dynasty *Ru* wares produced by the
imperial kilns in the Yongzheng reign period of the Qing dynasty. The
underside of the foot is coated with a sesame butter glaze to imitate the
white fireclay marks left on the bases of genuine *Ru* wares by spurs on the
base of the kiln. The blue seal script inscription of the base read, 'Made in
the Yongzheng reign period of the great Qing dynasty' (shown above left).

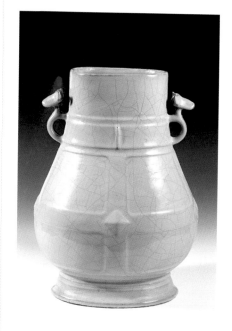

56
Guan-type Glazed Flattened _Hu_ Vase
Qing dynasty, Yongzheng reign period
Height: 4.7 cm

The form of this porcelain vessel is an imitation of a Han dynasty bronze. The relief designs and the ring beast handles also imitate those on bronzes. The smooth, lustrous green glaze and crackles emulate Song dynasty imperially produced _guan_ wares.

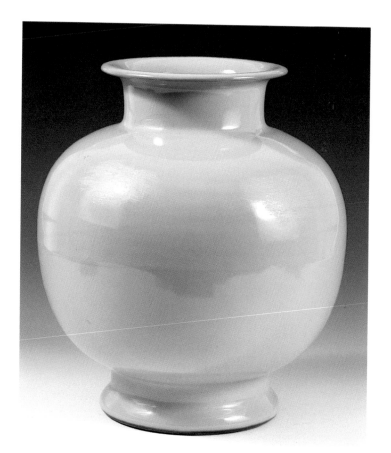

57
Ru-type Glazed Vase
Qing dynasty, Yongzheng reign period
Height: 27.3 cm

The modelling of this vase, with its flared rim, circular foot and slightly oblate body, clearly emulates an antique style. The greenish-grey glaze, the slightly darker glaze on the rim and the brown slip were all used to imitate a Song dynasty _Ru_ ware. There is no imperial mark on this object but it is an exquisite piece which was probably produced during the Yongzheng reign period of the Qing dynasty.

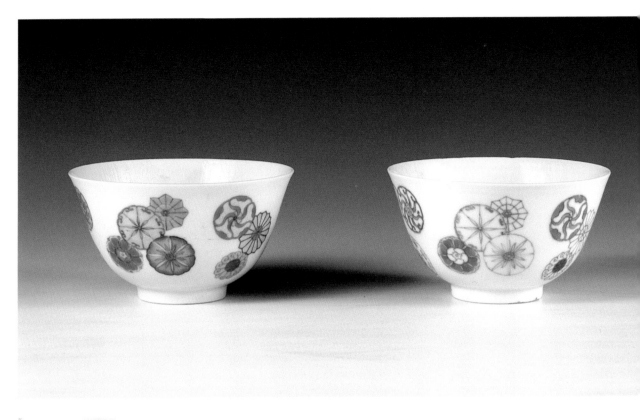

58

Pale Blue Glazed and *Doucai* Bowls with Floral Roundels

Qing dynasty, Yongzheng reign period

1723 – 1735

Height: 5.8 cm

These bowls are thin, light, strongly made and finely
finished with a pure and smooth glaze and a spheri-
cal decorative design, one in contrasting colours –
doucai – and the other in a pale blue glaze. The out-
line of the designs was first drawn on the bowl. After
high temperature initial firing, the colours are added
into the design and finally, the ware is baked again.
The patterns on these examples are clear and the
colours are bright and delicate. Six-character marks
in regular script are inscribed on the base of both
bowls within a double square, reading: 'Made in the
Yongzheng reign period of the great Qing dynasty'.
These bowls are made in imitation of the porcelain
wares produced during Chenghua reign period of the
Ming dynasty.

59
Reverse-decorated Blue and White Dragon Stem Bowl
Qing dynasty, Qianlong reign period
Height: 11.5 cm

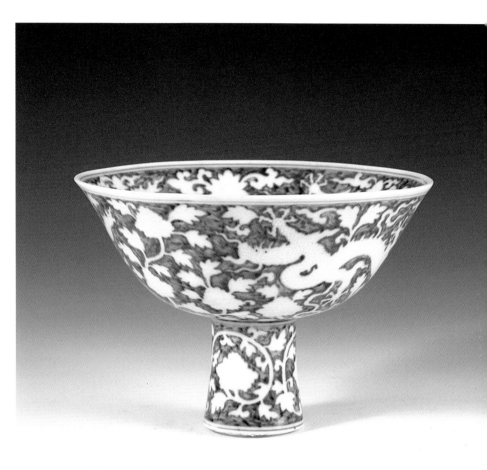

This fine light bowl is decorated on both the inside and outside with white dragons threading through lotus flowers on a blue background. The scales of the five-clawed dragons are exquisitely carved. The stem is embellished with interlocking peonies. The richness and density of the glaze is characteristic of the blue and white wares made under Yongle and Xuande reign periods of the preceding Ming dynasty but the six characters in seal script inscribed on the base (pictured right), read: 'Made in the Qianlong reign period of the great Qing dynasty'. Because it is such a good imitation of earlier blue and white wares, if it were not inscribed it could be taken as a genuine Ming dynasty bowl.
The Dictionary of the Cream of Chinese Cultural Relics has an entry for a stem bowl made under Yongle reign period of the Ming dynasty now in the collection of Beijing Palace Museum. The Beijing piece is most likely to be the model upon which this bowl was made as this is almost identical.

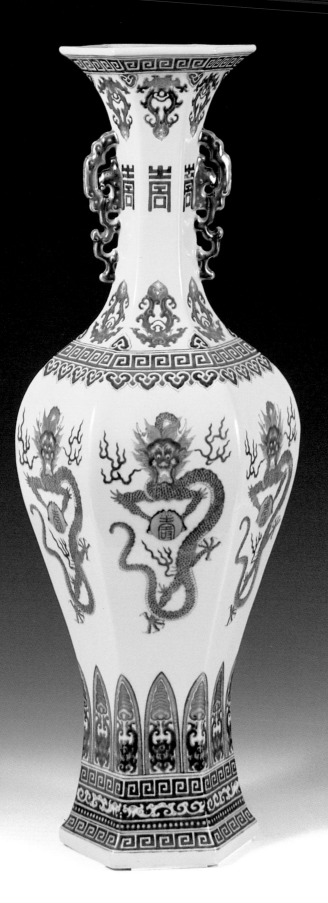

60

Yellow Underglaze Blue and White Hexagonal Dragon Vase

Qing dynasty, Qianlong reign period
Height: 57 cm

Although slender, light and delicate, this vase is strongly made and finely finished. It was developed from similar porcelain wares made in the Wanli reign period of the Ming dynasty. Its openwork double ears at the neck are, however, very characteristic of the porcelain products of the Qianlong reign period of the Qing dynasty. The rim and register below it are adorned with thunder patterns. Around the neck and on the shoulder are monster masks with the character for longevity – *shou* – drawn between the two registers, with another register of thunder patterns and *ruyi*-shaped clouds separating this from the main body of the vase. This carries the theme design of dragons holding the longevity character, one on each of the six sides. On the stem are decorative registers of plantain leaves, thunder and curly grass decorative bands. The decorative registers of thunder patterns are yellow painted on a blue ground while the theme design is blue painted on a yellow ground. On the base is a seal script inscription in blue reading: 'Made in the Qianlong reign period of the great Qing dynasty'.

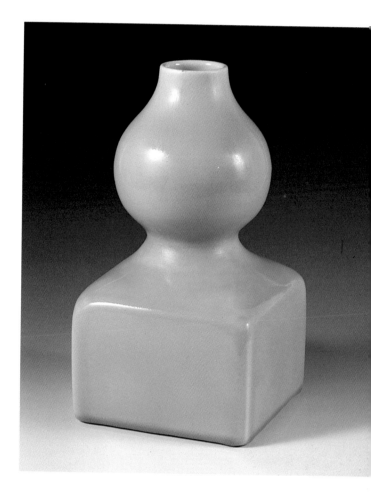

61

Celadon Double Gourd Vase

Qing dynasty, Yongzheng reign period
Height: 29.5 cm

This vase is a peculiar form, resembling a double-gourd with a square lower part and so symbolising the ancient Chinese idea of the universe with its round heaven and square earth. The outside and base are glazed in powder blue. The seal mark characters on the base read: 'Made in the Yongzheng reign period of the great Qing dynasty'.

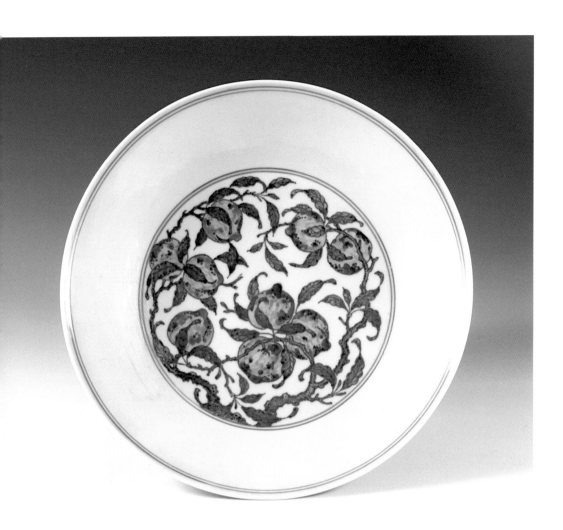

62
Blue and White Peach Dish
Qing dynasty, Qianlong reign period
Diameter: 27.1 cm

The plate is evenly coated with a smooth white glaze. Its centre carries a peach design and the back a design of interlocking convolvulus. The speckles of deeper colours were made deliberately to copy blue and white wares made in the Yongle and Xuande reign periods of the preceding Ming dynasty. The seal script inscription in blue on the base reads: 'Made in the Qianlong reign period of the great Qing dynasty' (shown left).

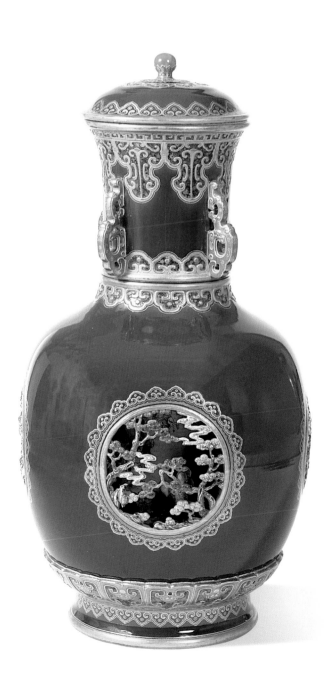

63

Gold Decorated Blue Glazed Reticulated Revolving Vase with the Qianlong Emperor in a Hunting Scene
Qing dynasty, Qianlong reign period
Height: 60.5 cm

This revolving vase is ingeniously constructed. It comprises six parts: the cover, the neck, the outer vase, the inner vase liner, the in-between compartment and the base. These parts are fired separately then assembled working from the inside to the outside and from top to bottom, the last stage being when the vase is seated on its base. The interstices are filled in and decorated in a golden colour. Finally, it is baked at a low temperature to fix the position of the inner vase liner. The background to a scene of the Qianlong emperor hunting is painted in *famille rose* enamels and then the emperor, his entourage and hounds are carved in ivory and hung in the relevant places on the painted background of the inner vase liner. Circular holes are cut in each of the four sides of the outer vase, in each of which are kneeling inlaid figures greeting the emperor. When the neck is turned, the bronze spinning device attached to it causes the inner vase to spin. Through the viewing holes the prostrated officials can be seen in the foreground while the emperor, attended by guides and body guards, appears to be approaching on a horse, with mountains just discernible in the distance. As the inner vase spins the scene of the emperor hunting unfolds, a truly amazing spectacle.

64

Blue and White Ewer and Lid

Qing dynasty, Qianlong reign period

Overall Height: 29 cm

This ewer was made in imitation of the blue and white wares manufactured under the Yongle reign period of the Ming dynasty. Gracefully modelled, it has a *ruyi*-shaped handle on one side, a long curved spout on the other, and a lid. The whole vessel is evenly coated with glossy white glaze. The neck is adorned with a plantain leaf design and the shoulder with an interlocking lotus design. The embellishments on the body are flower and plant designs with peaches inside roughly circular cartouches. The stem is embellished with a lotus petal design and the circular foot and mouth carry curly grass patterns. All the designs are in pure blue with deeper coloured spots, made deliberately in imitation of the style of similar products manufactured under Yongle and Xuande reign periods of the preceding Ming dynasty. The six character seal-script inscription on the base (pictured below) reads: 'Made in the Qianlong reign period of the great Qing dynasty'.

CERAMICS

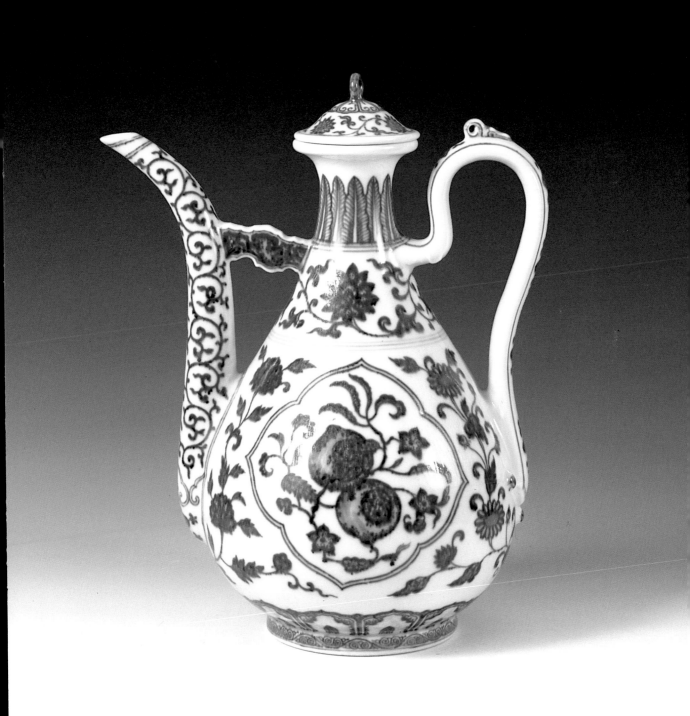

65

Imperial Engraved Porcelain Album with Scenes of Cotton Growing and Processing

Qing dynasty, Qianlong reign period

Lenght: 14.5 cm

This album comprises 34 porcelain folios bound in two volumes, volume one comprising 18 folios, and volume two, 16. The porcelain folios are mounted with gold sheets of paper between. 'An Ode to Cotton with Preface' by the Kangxi emperor is inscribed on the first two leaves. The other 16 plates are pictures of cotton growing and cotton weaving, showing the following scenes: Sowing; Irrigation; Ploughing; Pruning; Picking; Drying cotton in the sun; Sale and Purchase of cotton; Ginning cotton; Fluffing cotton; Making cotton rolls; Spinning cotton into yarn; Reeling yarns; Starching yarns; Fixing the yarns into the loom; Weaving and oiling the loom; Dying the cloth. The pictures were first carefully carved then painted. The pictures are vivid and include scenes from everyday life such as nursing mothers. Beneath the Kangxi emperor's poem are 32 anonymous seal marks of lines of poetry or famous sayings. On the opposite facing pages to each picture are more poems by the Qianlong emperor and the captions, all written in Chinese ink. This album is based on the set of charts describing the whole process of growing cotton and processing it into cloth created according to the direction of Governor Fang Guancheng in the 30th year of the Qianlong reign period (1765).

聖祖仁皇帝御製木棉賦并序

練而爲絮溫光爭殊御寒儗井序
木棉爲利於人溥矣衣被豪於萬氓
膚白雪卻卻潘秋書於臨軒氈氍佐春耕
此事陽迎寒女之門晉官晏斷於里閭佐春耕
布邊譬以爲統卒紙之課出之離離窮方其庶
之膏而未嘗徧植於東土故取禮用異種也足止以克達方
緘之司津正蓬寒之申人月歿半衣之遮霜侵萬蘿之原
家機千籍之績嫗繞之難兔子貉之難草紋夭八口之家
兩冶此眼熟泛膺之庸製牽病家之飼日曩田租
九土之眠鷹蠶言藏之除草時秋時春豐之梅
水耕歲蕃三種之棉楊登蠶吐蠶此火大平
萬嵐葇組之言與夫編絞之輕賤鳳詩之米語晳方問俗
將稍曲什術補煥煥衣之纓

五色爰論精與粗焉筥卒歲此
殷需布棉題句厪民瘼敦績
神堯耕織圖
乙酉清和月御題

橫律絚經織帛同夜深軋
郎停工一般機杼無花樣大

布帛百納文緜棱之巧後人奮畫七經小帳窄句知爲色志
緜藏素之言倍爾爲斯之緜爲至八織帛帖纷於和而二中
縷行自奪趣超長帳爲色之工緜緜帖倍緜於和而二中亭
亦中擬製力恋遺村云

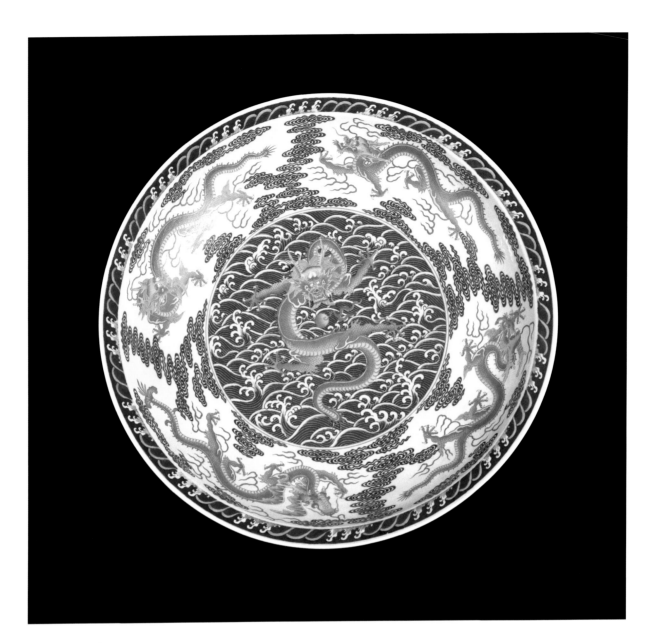

66

Blue, Red and White Dragon Dish

Qing dynasty, Qianlong reign period

Diameter: 47.8 cm

This large plate is strongly made but is neither thick nor heavy. The white underglaze is pure and evenly applied. The purplish blue is particularly appropriate for the wave design surrounding the central dragon, depicted in red. Both the front and back are decorated with another design of four red dragons roaming among blue clouds. The seal-script inscription inside the circular foot reads: 'Made in the Qianlong reign period of the great Qing dynasty' (shown left).

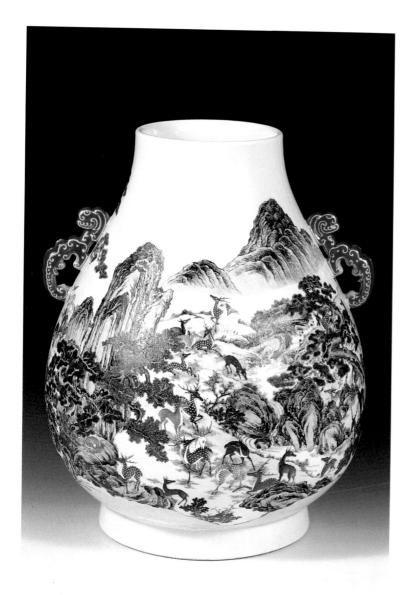

67

Hundred Deer *Famille-rose Zun* **Vase**
Qing dynasty , Qianlong reign period
Height: 45.3 cm

The painting, in *famille rose* enamel over-
glaze, shows numerous deer in a landscape,
some hidden among the trees so that only
their head or legs are visible, making it very
difficult to count precisely how many deer
are depicted here. Since the word for deer in
Chinese is homonymous with prosperity,
this picture symbolises much good fortune.
The vase has two openwork dragon handles
and a circular foot. The seal script blue
inscription on the base reads: 'Made in the
Qianlong reign period of the great Qing
dynasty'.

CERAMICS

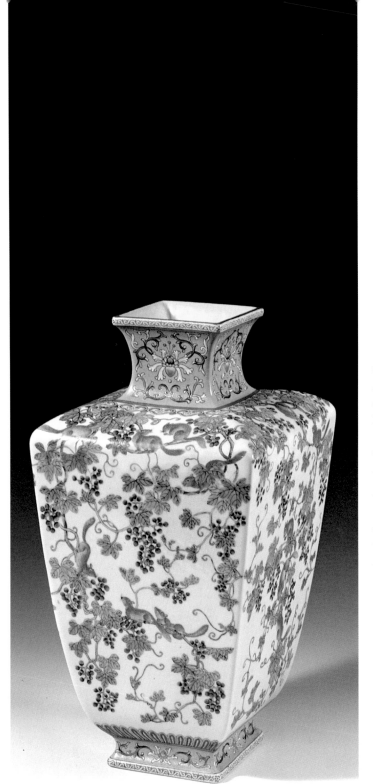

68

Famille-rose Square *Zun* Vase

Qing dynasty, Qianlong reign period
Height: 30.5 cm

The rim of this sturdy *zun* vase is painted gold on
top with a design in blue of curly grass on a white
ground on the sides. A *famille rose* design of
Buddhist treasures is painted on the neck on a pink
ground. Between the neck and the shoulder is a
circle of blue *ruyi*-shaped clouds on a yellow
ground. The theme design of squirrels and grapes
is painted below this, on the shoulder and body of
the vessel. Twenty-four squirrels are leaping
among grape vines. The squirrel and grape vine
design symbolizes numerous children and is also
found on bronze mirrors. Chinese tradition holds
that the more children one has the more blessings
one will enjoy. The decorative designs on the foot
are the same as those on the edge of the rim. The
interior of the neck and the bottom are glazed in
water-green while the inside is thinly glazed with
white. A red seal-script inscription inside a white-
glazed square on the base of the vase reads: 'Made
in the Qianlong reign period of the great Qing
dynasty'.

69
Celadon Brush Washer with Dragon Handles
Qing dynasty, Qianlong reign period
Height: 2.7 cm

This elliptical brush washer has a flared rim, a flat bottom and a shallow circular foot with four horseshoe shaped feet. On either side is a dragon-shaped ear holding the rim in its mouth and with a tail resembling a curly grass pattern. The exterior surface of the washer is decorated with a relief design. The modelling and glaze are both very elegant. A seal script inscription on the base reads: 'Made in the Qianlong reign period of the great Qing dynasty' (pictured below).

70
Group of Feather Holders
Qing dynasty, Tongzhi reign period
Lengths: 4.2 – 5.9 cm

During the Qing dynasty the hats worn on official occasions by court officials and the Manchurian and Mongolian nobility were decorated with peacock or pheasant feathers. Porcelain tubes, such as those shown here, were used to fasten the feathers on to the hats. This set of tubes includes some with *famille-rose* and some with a turquoise glaze. Among those glazed in the former are examples on both white and green grounds. The plethora of decorative designs which symbolize longevity, wealth, official success and happiness include Buddhist treasures, peaches, swastikas, bats, and longevity – *shou* – characters. Some of the tubes are embellished with white nipples in imitation of pearls.

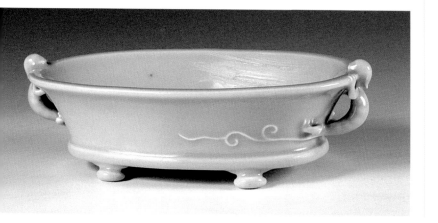

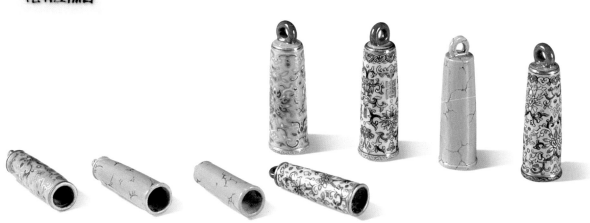

Lacquer wares have been found in Chinese tombs dating from as early as 3,000 BC and are thus an integral part of both Chinese and world culture. Lacquer continued to be made throughout Chinese history and reached an apex during the affluent years of the early Qing dynasty, building on developments made in the Ming. To meet the demands of the time and because of influences from other crafts, a new style emerged and several examples of this have been preserved to the present day. The most popular lacquers were those with abundant, fine and delicate carved designs. A department in the imperial palace specialized in manufacturing goods exclusively for the imperial family and, in addition, places like Yangzhou and Suzhou sent exquisite lacquer wares as tributes to the court. Some fine examples can be seen in the Nanjing Museum.

LACQUER

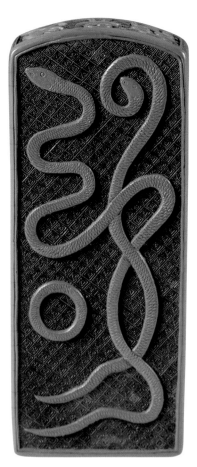

71
Carved Lacquer Daoist Emblems
Front and back covers illustrated.
Ming dynasty, Jiajing reign period
17.5 x 7 cm

This red lacquered hexagonal wooden
article is rectangular in shape. Its top is
slightly arched. Both sides and the four
edges are all decorated. Two entwined
snakes are engraved on the front side,
symbolising the complementary forces of
yin and *yang*. The seven stars of the
Northern Dipper constellation are carved
on the side edges. The back and top and
bottom edges are all decorated with Daoist
secret talismanic writings comprised of
curly tiny snakes. Minute colourful spots are
carved out between the various designs in
an ordered design. The whole object is
made with excellent workmanship, and was
used in Daoist rituals performed in the
Ming dynasty imperial palace.

72

Imperial Carved Lacquer Box with Lid

Qing dynasty, Qianlong reign period

12.6 x 5.1 cm

The outside of the square red-lacquered wooden box and its lid is decorated with designs of horses swimming among waves. Four characters in regular script are inlaid with gold in the inside of the cover (pictured above right) and read: 'Ze Ma Bao He' (Water Horse Precious Box). The six characters in the box (above left) read: 'Made in the Qianlong reign period of the great Qing Dynasty'. The whole article is exquisitely executed. The thick lacquer is a bright and pure red and the carving is extremely skillful. The waves are expressed with lines as thin as hair and they are cut with consummate precision with no sign of any breaks.

73
Carved Lacquer Monkey Dish
Qing dynasty
Diameter: 58.4 cm

This red round plate is made from a core of wood. It has a
straight mouth, a shallow belly, a thick wall and a short
circular foot. In the centre of the plate three monkeys are
relief carved in a realistic and vivid style as if depicted with a
Chinese brush rather than the sculptor's knife. They depict
the 'See no evil, hear no evil, speak no evil' motif.

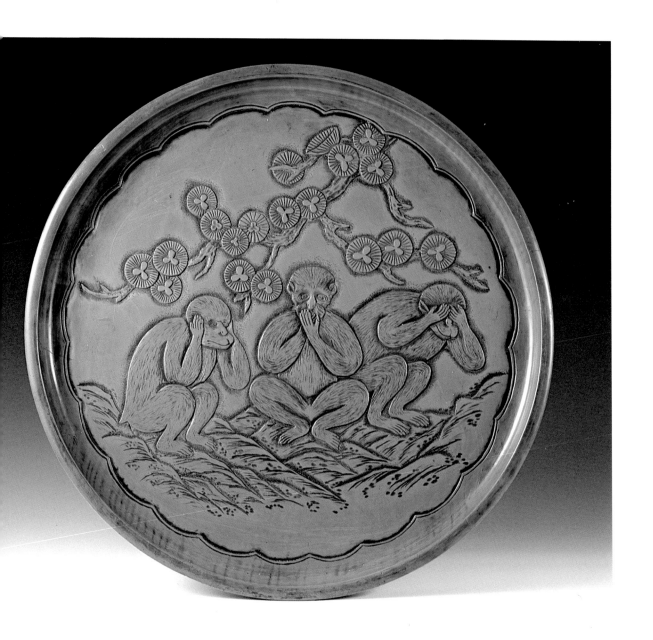

74
Painted *Ruyi*-shaped Lacquer Box and Lid
Qing dynasty
27 x 18 x 6.5 cm

This *ruyi*-shaped wooden box has a wooden core
and four round feet. It was originally made to hold
'His Imperial Majesty's Ode to the Grand Capital'
copied by Cao Zhengyong. The designs are
painted with red, white, green and brown colours
on a plain ground. The top of the lid depicts the
character for longevity – *shou* – surrounded by the
double lozenge symbol of victory and flowers and
fruits. The side is decorated with the eight
Buddhist auspicious signs: wheel, conch, umbrella,
canopy, lotus, jar, fish and mystic knot. The
colours are still bright and the drawings exquisitely
executed.

LACQUER

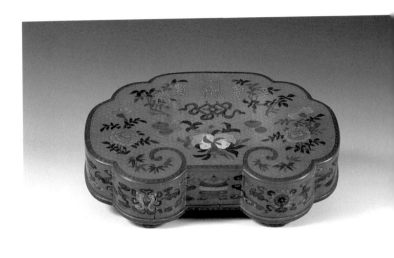

75
Carved Lacquer Barbed Dish
Qing dynasty
Diamter: 33 cm

This red-lacquered wooden dish has a flared mouth and a short
circular foot. It is adorned with an intricate design of stems and flowers
on the underside, a meander pattern on the outer rim and then rings of
supplementary designs sculpted towards the inner circle of the dish.
Here is depicted a scene from an ancient Chinese legend, 'The Cowherd
and the Weaving Maid'. This tells of a couple, two stars, who fall in love
and marry on earth. When they return to the skies they are so happy
together that they refuse to work and are punished by being separated by
the Milky Way. Their grief is so evident that their punishment is mitigat-
ed: they are allowed to see each other once a year on the seventh day of
the seventh moon, when magpies form a bridge across the Milky Way.
This image shows the Weaving Maid crying on one side of the Milky
Way while her husband stands on the other side with their son and
daughter.

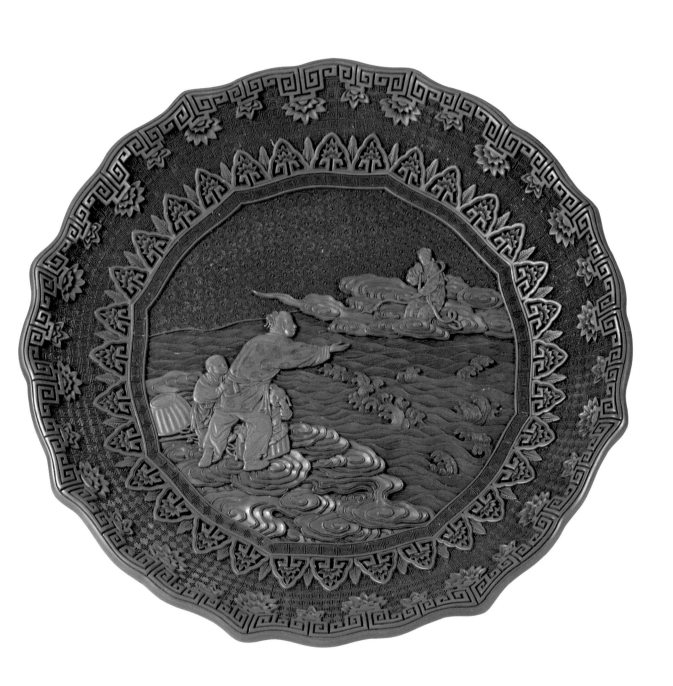

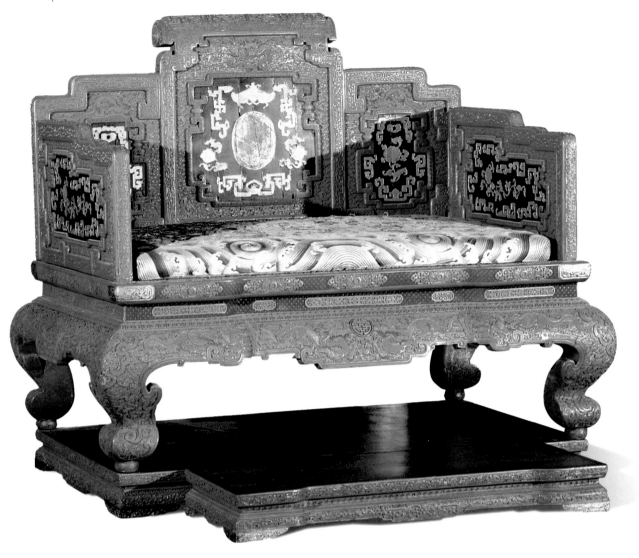

76
Imperial Carved Lacquer Throne
Qing dynasty
Length: 150 cm
Width: 90 cm
Overall height: 140 cm

This red-lacquered wooden imperial throne stands on a pedestal with a foot-stool in front. The throne is covered with designs of flowers, dragons, bats, clouds, meander patterns, and other traditional symbols. The back of the throne and the armrests are decorated with designs of lotus flower painted in gold and black lacquer. The workmanship is perfect. It was originally used as the emperor's throne in the Summer Palace at Chengde, north of Beijing having been sent as tribute by the administration of Yangzhou, a city on the south bank of the Yangzi River, in the late Qing dynasty.

LACQUER

77
Carved Lacquer *Ding*
Qing dynasty
Height: 35 cm

This red lacquered wooden *ding* – three or four legged cooking pot – is composed of three parts: the pot, lid and stand. The stand is rectangular in shape with cloud-shaped feet. On the stand meander, brocade and floral designs are finely and densely sculpted. The cover is adorned with various designs such as the meander, lotus, brocade and floral designs. The pot has two upright ear handles, emulating ancient bronze *ding*. Designs of anecdotes of outstanding historical figures are carved on the four sides, for example, 'Wang Xizhi admiring geese' and 'Tao Yuanming enjoying chrysanthemums'.

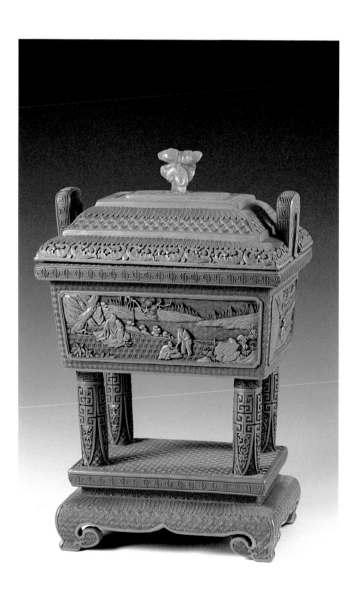

78
Carved Lacquer Imperial Sutra Box and Lid
(with sutras inside)
Qing dynasty, Qianlong reign period
16 x 7 x 25cm

Made during the Qianlong reign period of the Qing Dynasty, this box was for imperial court use and contained the 'Imperial Selection of Buddha's Primary Teachings'. The inscription 'Made in the Qianlong reign period of the great Qing Dynasty' is on the front of the box flanked by designs of dragons and clouds. The top and the two edges of the box are also decorated with dragons - the imperial symbol. The verso shows the Buddhist scene of vanquishing demons. Śākyamuni, the historical Buddha, sits on the centre top with his hands in the gesture of subjugating the evil spirits. One big devil and two small demons are being crushed under his lotus pedestal. Altogether, one hundred and thirty-seven Buddhas, *luohan* and heavenly kings are carved, each bearing a different expression. This is a unique masterpiece.

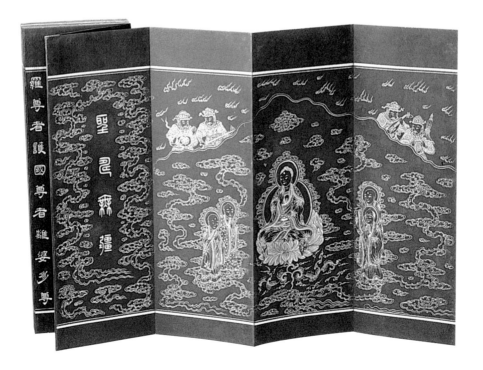

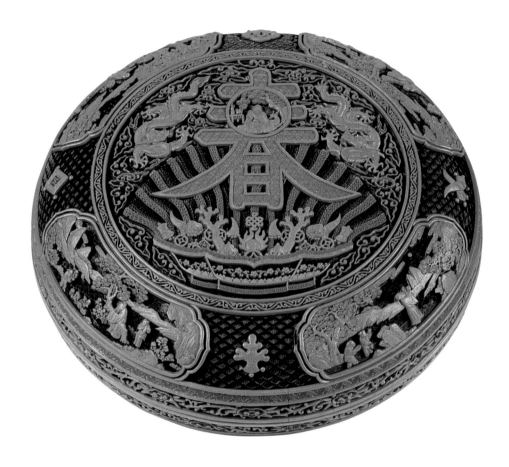

年乾大
製隆清

壽春
寶盒

79
Carved Lacquer Imperial Box and Lid
Qing dynasty, Qianlong reign period
Diameter: 35.7 cm

This round, wooden box was used in the imperial palace to hold refreshments. In the centre of the cover the character *chun* (spring) is carved. Within this character the figure of a god of longevity is carved on a circular blank ground. Beside the figure there are designs of pine trees, bats and deer, symbols of longevity, wealth and happiness. Designs of dragon and clouds are carved on either side of the character. Below is a treasure collecting box containing coral, ivory, rhinoceros horn, and silver ingots. There is a design showing beams of three colours radiating from the box in all directions. The sides of the cover and the box itself are decorated with similar designs and patterns. There are four cartouches on the edge of the box with designs of treasures such as ornaments, rhinoceros horns and jewels carved between them. Inside the cartouches historical scenes are depicted. On the base is a gold-inlaid inscription in regular script reading: 'Made in the Qianlong reign period of the great Qing dynasty'. Another inscription in regular script reading 'Longevity and Spring Box' is carved on the inside of the cover (both inscriptions pictured left).

A wide variety of decorative arts were developed in China, with bamboo and wood carvings being common. The most famous masters of bamboo carving were Pu Zhongqian and Zhu Songlin of the Ming dynasty. Wood carving was better developed in the south-east of China where rosewood and mahogany were valued as the best media. Jade carving also reached its peak in the Ming and the Qing dynasties. Jade of exquisite quality was worked on an unprecedented scale. Among the stone-carved artefacts, ink-slabs commanded appreciation and admiration from scholars and connoisseurs. Cloisonné is another of the decorative arts characteristic of China, a process whereby coloured glass paste is contained within intricate and complex wire patterns which have been glued or soldered on to the bronze mould. The whole item was then fired at a low temperature to melt the enamels, resulting in brightly coloured and highly decorative items. Examples of all these decorative arts are found in the Nanjing Museum.

WORKS OF ART

80
Duan Inkstone
Song dynasty
23.3 x 14 x 4.8 cm

Excavated from a Song period tomb, this copyist inkstone is made of *duan* stone. Copyist inkstones are characterised by being two to three times thicker than ordinary ones. The underside of this example has been cut away so that it rests on three sides making it lighter and thus possible to hold in one hand. Other forms of inkstones need to be held with two hands when being moved or washed. Its weightiness and rectangular form are typical of the 'copyist' shape. The fine, smooth textured stone is purplish-brown and has two patches of different colour near the mouth resembling eyes, and typical of this stone. It has been burnished and is an outstanding example in terms of quality of the stone, its colour and eye patterning.

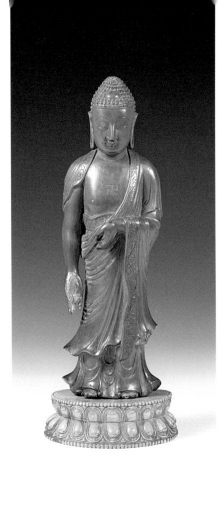

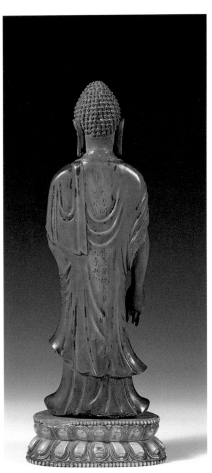

81
Yellow Sandalwood Carving of a Standing Buddha
Ming dynasty
Height: 25 cm

This standing statue shows Buddha wearing the traditional patched monk's robe – *kasaya* – leaving his right shoulder uncovered. The statue is carved from yellow sandalwood and stands on an ivory lotus pedestal. There are traces of gilding on the surface and two columns of characters engraved into the back of the statue, which read 'Made by Mr. Yang Fuzhi in the western hall of Qianfu Temple in the twelfth year of Kaiyuan reign period of the Tang dynasty (725).' The calligraphy is poor and is clearly a forgery added later to try to make the statue seem older than it is. There is also an inscription of five characters in professional calligraphy in small seal script carved at a spot concealed by the lower part of the *kasaya* which reads: 'Worshipped in the Pavilion of the Music of Nature.' The Pavilion of the Music of Nature was the library of Xiang Yuanbian, a famous book collector of the Ming dynasty.

82

Bamboo Carving of a Fisherman

Ming dynasty

Height: 15 cm

Following the natural shape of a bamboo root, the sculptor portrays in openwork a big fishing basket, on which sits a fisherman with a small basket hung round his waist. While balancing himself by pressing his left hand on the big fishing basket, the fisherman jubilantly carries two squirming fish in his right hand. Below the fishing basket, waves and crabs are carved as background. There are vivid touches in this refined and succinct carving.

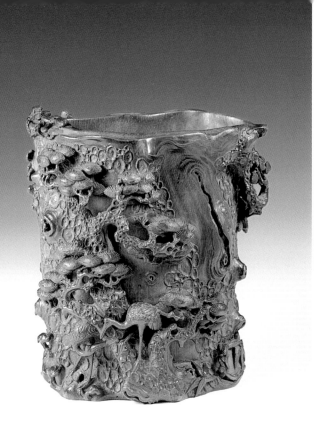

83
Bamboo Brush Pot by Zhu Songlin
Ming dynasty
Height: 17.7 cm

The sculptor of this object, Zhu Songlin, was a well-known Ming dynasty master craftsman, an expert in calligraphy, painting and seal cutting, and also a poet. He excelled at carving bamboo. Unfortunately, very few of his works are extant. This brush pot is in the form of a huge trunk of an old pine tree with a gnarled mottled bark. The design shows a pair of cranes among younger pines and a stream. The carving is intricate and vivid, the pine needles being particularly fine. There is a long inscription in elegant calligraphy engraved on the back, from which we know that this artefact was carved as a birthday present to a friend. The design and carving skill fully demonstrate Zhu Songlin's outstanding achievements in bamboo carving.

84
Bamboo Brush Pot by Pu Zhongqian
Ming dynasty
Height: 15.9 cm

Pu Zhongqian was from Jinling (present-day Nanjing), and was born in the tenth year of Wanli reign period of the Ming dynasty (1582). He was a famous bamboo sculptor. This brush pot by him is decorated with the scene of 'Eight Immortals Crossing the Sea'. The immortals are on a raft made of an old pine root. The sea is rough but the immortals remain composed in the face of roaring waves and billows, showing their divine poise. Above, a scene of overhanging precipices and steep cliffs, with flying cranes and thin clouds, indicate the location of the immortals, forming a sharp contrast to the rough sea. The designs are in bold relief sculpture and convey both a sense of distance and shading.

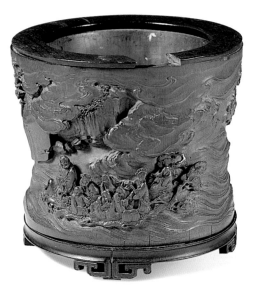

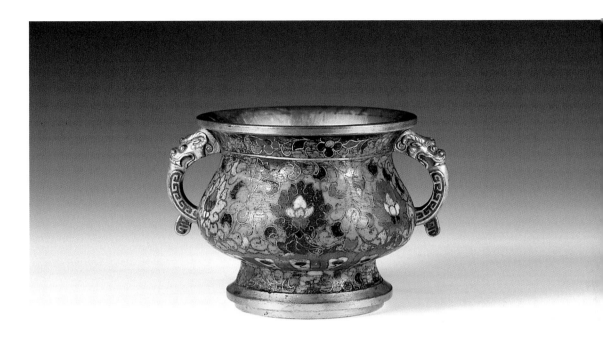

85

Cloisonné Animal Handle Censer

Ming dynasty, Jingtai reign period
Height: 9.4 cm

The brim turns outward and is gilded. Between the neck and the belly there are gilded beast heads that curl up to form ear handles of the censer. The belly, neck and the lower portion of the censer are decorated with blue, yellow, red, white and black designs on a bluish-green ground. The bottom is convex and carries a square relief incription in regular script reading: 'Made in the Jingtai reign period of the great Ming dynasty'. *Cloisonné* enamelling technology was pioneered in the Tang dynasty, although inlay of metalwork with glass and glass paste had existed as early as the Shang dynasty in China. The technique became very popular in the Jingtai reign period of the Ming dynasty, which saw the finest blue glazed examples, thereby known as 'Jingtai Blue'.

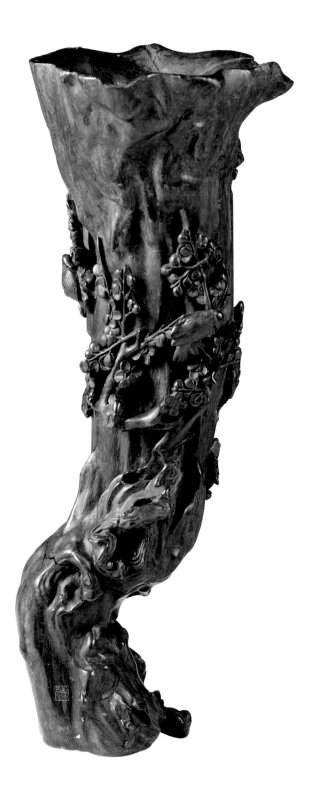

86
Red Sandalwood Relief Carved Flower Vase
Qing dynasty
Height: 35 cm

Carved in the shape of snaking plum branches, the vase stands erect with a flared mouth. Bold relief sculpture and openwork techniques are employed to depict plum flowers on the body of the vase. There are three pairs of magpies in various postures perched on the plum branches, magpies being birds of good omen (the Chinese name for magpie is literally 'bird of joy'). A square seal mark is cut in relief on the base, reading: 'Made by Zhu Qingfu' (pictured below). Thus we know that this vase was the work of Zhu Ying (known also as Qingfu), a well-known wood and bamboo sculptor of Jiading County in the late Ming and early Qing dynasties.

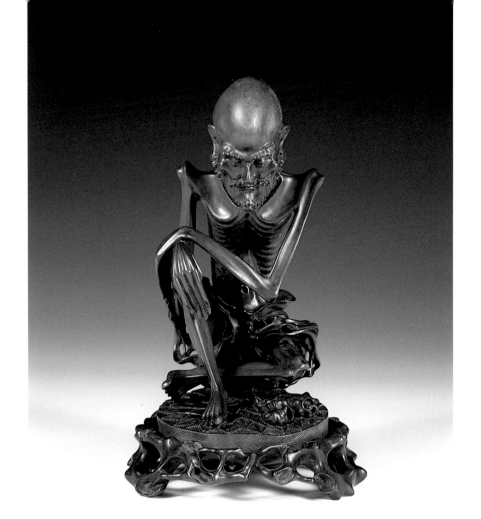

87
Wood Carving of an Ascetic
Qing dynasty
Height: 20 cm

This woodcarving is based on the story of Bodhidharma, the monk who is claimed to have introduced Indian meditation techniques into China from India in about the sixth century. He lived for nine years in a temple in China where he remained in meditation facing a rock for the entire period, thus losing use of his arms and legs. The skeletal ascetic depicted here sits on a rush mat with crossed legs, his torso naked. He seems to be in a state of deep meditation, within which he is completely detached from sensual pleasures and free from human desires and passions. Though this is a small wood carving, it is in proportion and natural, and there are no traces of cutting or polishing.

88

Duan Inkstone by Gu Erniang

Early Qing dynasty
Diameter: 8 – 14 cm

Gu Erniang, a native of Wumen (present-day Suzhou in
Jiangsu Province), was famous in her own time for
making smooth and elegant inkstones. This example,
made from *Duan* stone is shaped like a lotus leaf, with
veins of the leaf and fibrous roots carved at its base.
Between the leaf veins a seal mark 'Erniang' is cut in
relief. The texture of the grinding area is so smooth and
fine that ink can almost be produced simply by blowing
on it and it cannot damage the delicate hairs of the
brush. The stone comes from Shaoqing, Guangdong
Province. In ancient times, Shaoqing was called Duan
Province, hence the name *Duan* inkstones. They were
held to be the best.

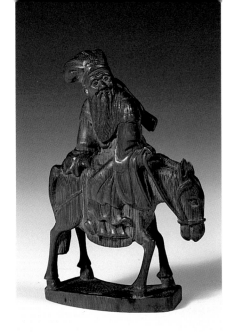

89
Bamboo Carving of Zhang Guolao Riding on a Donkey
Qing dynasty
Height: 10.3 cm

This object is carved from old bamboo with thick stem walls. Zhang Guolao, an eighth century Daoist recluse and one of the Eight Daoist Immortals, is shown riding his trademark white mule backwards carrying a drum. When he stops, he folds up the donkey like a sheet of paper and puts it into his wallet. When he next needs to use it, he turns it back into a donkey by squirting water on it. The Eight Daoist Immortals was a prevalent theme in ancient Chinese art. The carving skill, which combines openwork and relief sculpture, is excellent. This graceful and yet simple work of art is a rare treasure for the scholar's desk.

WORKS OF ART

90
Carved Rhinoceros Horn Cup
Qing dynasty
Height: 8 cm

In traditional Chinese medicine rhinoceros horns, young deer antlers, musk and antelope horns are regarded as four precious medicines. Rhinoceros horns were also a precious raw material for sculpture in ancient times. Top quality rhinoceros horns are darkish yellow in colour and have a smooth glossy appearance, and the elite in ancient China valued rhinoceros horn wine cups. Meander patterns and animals are carved around this example. The upper part of the handle is decorated in relief with coiled double dragons, which lie half way round the lip.

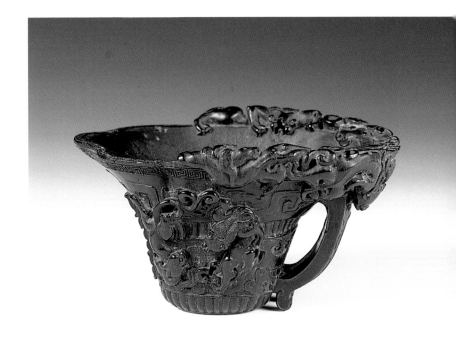

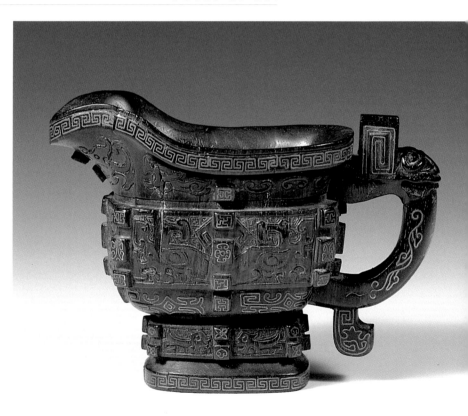

91
Boxwood *Ruyi* Sceptre
Qing dynasty
Length: 29 cm

Ruyi was originally a utensil made of jade,
metal, bamboo or wood, with one end shaped
like a sacred fungus, a cloud or a heart. The
name *ruyi* means 'as one wishes' and it
developed into an auspicious decorative
object. It was also used as a Buddhist symbol
where it was identified with the lotus. This
example, carved from boxwood, is in the form
of entwined lotus stems, leaves and buds,
carved in a natural and fluent shape.

92
Archaistic Red Sandalwood *Guang* with Silver Inlay
Qing dynasty
Height: 10.1 cm

Bronze cups of this form – *guang* – were used by the Shang and Zhou elites as wine containers at ban-
quets or in rituals and frequent references are made to them in the ancient collection of poetry, *The Book
of Songs*. The *guang* form typically has a spout, an animal head handle, an elliptical flattened belly, and
four legs or a circular foot. The shape and decorations of this *guang* carved out of red sandalwood are in
imitation of ancient Chinese bronze wares. Shallow relief carving of monster – *taotie* – masks are found
on three sides. The handle is a column of water spouting out of an animal head. The rim, base rim and
handle are all inlaid with silver threads in imitation of the silver inlay technique used on bronze vessels.

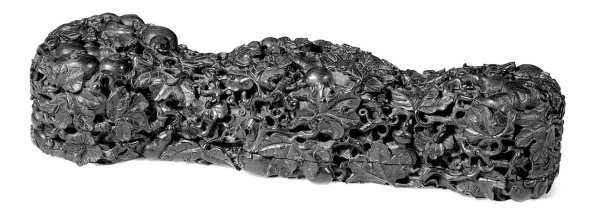

93
Mahogany *Ruyi*-shaped Box with Lid
Qing dynasty
Length: 46.5 cm

This box was a gift box to the Jiaqing
emperor on his accession. The box origi-
nally contained the donor's paintings and a
set of jade carvings. Made from top quality
mahogany and of the highest standard of
workmanship, it takes the form of a *ruyi*
with designs of bottle gourd flowers and
leaves symbolising prosperous descendants,
good fortune and happiness – a metaphor
that the kingdom of the Qing court will con-
tinue without end. The sculptor showed
brisk and neat chisel work and an impres-
sive style.

94
Mahogany Brush Washer
Qing dynasty
Diameter: 28.7 cm

The production of brush washers dates to ancient
times. It increased in the Tang dynasty, and
peaked in the Ming. There were countless brush
washers of various styles and shapes made of
different materials for the appreciation of the
scholarly class. This example is in the shape of
a lotus leaf with carved designs of a crab, gecko,
toad, river snail and clam. They are all realistically
depicted.

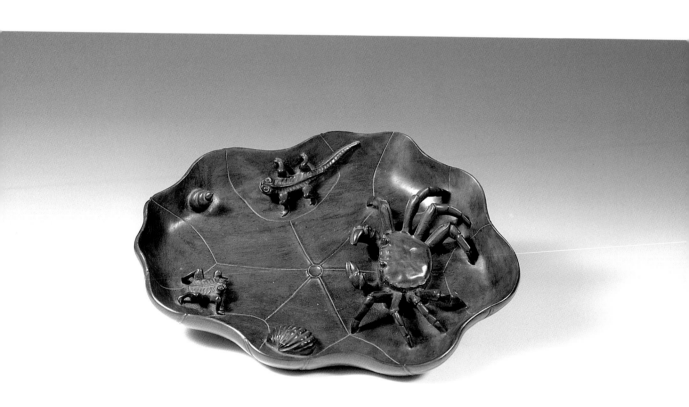

Silk was discovered in China and sericulture developed there by the fifth millennium BC. Silk weaving matured over the following millennia to become highly refined and technically complex. Embroidery, originally used to repair or join cloth, started to be used decoratively in the first millennium AD and *kesi* (slit silk) tapestry was probably introduced into China from Central Asia by the tenth century. From the Song dynasty (960-1279), craftsmen started to use these different techniques to imitate Chinese painting and calligraphy using textiles. As well as Song embroidery and Gu embroidery of the Ming dynasty, different regional styles developed, among them Suzhou, Changsha, Guangdong and Chengdu embroidery: all important in the development of the art of 'painting' in textiles.

PAINTING AND EMBROIDERY

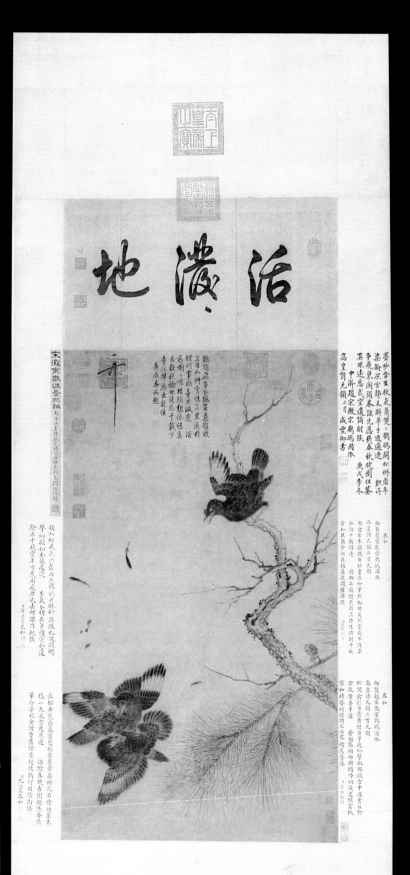

Imperial Painting of Birds by the Song Huizong Emperor

Northern Song dynasty, Emperor Huizong
(r. 1101-1125)
88.2 x 52 cm

Huizong (r. 1101-1135), eighth emperor of the Northern Song dynasty, was an outstanding calligrapher and painter, skilled at depicting flowers, birds and landscapes. He was famous for the minute and exquisite detail of his works. His calligraphy style known as 'slender gold' was unique. This painting of fighting mynah birds on an ancient pine was admired by the Qing dynasty Qianlong emperor in the eighteenth century. The text at the top of the picture is a poem written by him, accompanied by his large red square seal with his signature 'Tian xia yi ren' (First under Heaven) inscribed in black ink on top. There are other seals of his on the painting and poems on the surrounding mount expressing comments on the picture. The Qianlong emperor's text alludes to the loss of northern China in 1127 and reads: 'Pecking and clawing, feathers flying in all directions, the mynahs fight.
A third sits on a branch, his black bean eyes showing his alarm.
I see this this painting as an historical allegory. Why did the empire enter into an alliance with Jin to attack Liao?
Birds' lively singing in the branches is reminiscent of the cheerful prosperity of the big mountains of that lost land.
One thousand years have passed since these events. and my regret is thus in vain. Written by the emperor in the spring of the *gengchen* year'.

96
Embroidered Picture of Bodhidharma Crossing the River
Song dynasty
46.3 x 30.2 cm

Embroidery evolved from being used in the production of
purely utilitarian articles to the creation of works of art
during the Song dynasty. The famous Ming dynasty
painter, Dong Qichang (1555–1636), even said that 'fine
embroidery can exceed painting.' This picture is one of the
rare pieces of Song embroidery to survive. It shows
Bodhidharma, a Buddhist monk from south India who
came to China in the late fifth century, using his magical
powers to cross a river. It became a very popular subject for
paintings in the centuries following the Song. This example
combines embroidery and painting. The scenery of the river
and the reeds are painted but the figure is embroidered in
silk thread. The outer garment is embroidered in yellow silk
and the decorative patterns and undergarments are in blue.
This style of combining painting and embroidery had a pro-
found influence on the Gu embroidery of the Ming dynasty.
At the top of this picture there are inscriptions by well-
known historical figures such as Ou Dashi and Chen
Benzhong. Though no identification mark was given, we
can be certain that this piece was the work of a master.

面壁公可相吾身本不有色作如是觀直

須棒喝走　似日居士領大典

東行震旦辛渡蘆帶江色見性成佛

心影幻中嵩壁　歐大任

折蘆與面壁幻相不去依翻咲惹

山比細、隻復摒　無錫居士方祀

来従何方来去没何處去色相住他傳我

心本無与　氣虚衛入程本中

隻履既說西歸此中何更有汝虛傳一燈三

燈鼓普千縷萬縷若不惠我三昧長龍

頂禮柔補闡提逯我闡提佛祖讓你佛

祖　違磨像

太空居士程可中為黃徽美家本宋絲

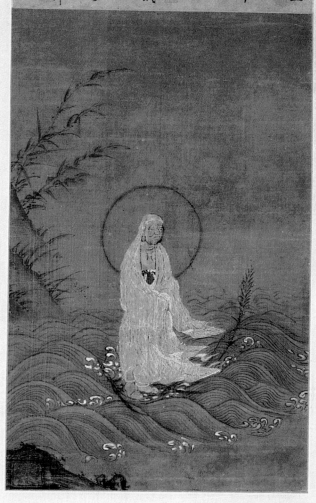

97
Kesi **Picture of Buddha**
Southern Song dynasty
112 x 30 cm

The *kesi* tapestry technique introduced into China by the end of the first millennium flourished during the Song dynasty. Outstanding artists emerged and produced many works of the highest quality. This *kesi* tapestry made by an anonymous artist represents the apogee of Southern Song *kesi* technique. This figure of Buddha is portrayed in three different shades of blue by embroidering designs on a light blue ground. The clouds and the Buddha's clothes are in reddish blue, the far ends of sleeves and the beard in dark blue, and the lotus, umbrella and *ruyi*-shaped heads in light blue embellished with golden threads. The colours of this tapestry remain bright and elegant. The Buddha's benign face and quiet smile are vividly portrayed. The craftsmanship is superb. The textile is mounted and various collectors have added their seals and comments on the work to the mount surrounding the picture.

PAINTING AND EMBROIDERY

98
Embroidered Portrait of Guanyin by Guan Zhongji
Yuan dynasty
104.9 x 49.8 cm

Guan Zhongji (1261 – 1319) was the wife of Zhao Mengfu, a famous Yuan dynasty artist. She was also skilled at painting, as well as calligraphy and embroidery. This embroidered portrait of Guanyin, the Goddess of Mercy, is among the small number of her extant masterpieces. This piece was embroidered on a twill ground using both hair and silk in satin and other stitches. The bare-footed Guanyin holds a rosary in one hand. Her flowing black hair was embroidered using Guan's own hair as thread in order to show her great piety towards the Buddha.

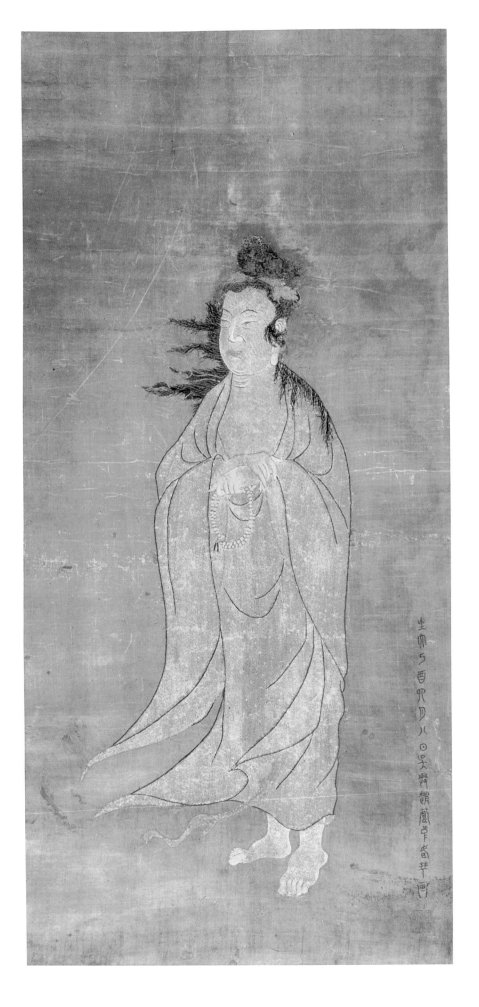

99
Embroidered Picture of Willows and Horses by the Gu Family
Ming dynasty
124 x 43 cm

The distinctive style of the Gu family in Shanghai in the Ming Dynasty became known as Gu embroidery. It developed features of Song dynasty embroidery and also emulated painting techniques to create a charming, lively style which was very influential on later generations. This depiction of horses being washed among willow trees is an imitation of 'Washing Horses' by Han Ximeng. The original blueprint was probably the work of Zhao Mengfu, a Song dynasty painter. Although this version has some additional details it does not look messy, showing the artist's skill. A variety of stiches have been used to produce realistic depictions of both the humans and animals. In some places brush strokes have been added to unify the picture.

100

Imperial *Kesi* Album of Landscapes

Qing dynasty, Kangxi reign period

18 x 12 cm

Kesi is a tapestry technique where the patterns are formed by the weft threads which do not run through the whole width, thus leaving gaps and making it somewhat akin to openwork carving. *Kesi* became popular during the Tang dynasty and saw further development during the Song. Early Qing *kesi* were simple and rough but after the Qianlong reign period they became complex and intricate. These album pages of landscape reflect the early Qing style.

於赫尊神斯文
樞紐正直聰明
形古貌醜目攝
眾星足躁九有
筆大如椽擎天
巨手德旺於東
班居其右世人
昕知一錠一斗

戊寅中秋顧熾昌敬書

乾隆戊寅中秋朱嫩庚編

101

Embroidered Picture of the God of Literature

Qing dynasty, Qianlong reign period

72.8 x 40.3 cm

The legendary god of literature, Wen Chang, is reputed to live in that part of the constellation of *Ursa Major* known as *kui* in Chinese. The candidates who came first in the Chinese civil service examination – a literary test – were therefore called *Kui* and scholars gave offerings to this god to ask for scholarly honours and an official post. The god was often depicted in the form of a ghost with his foot on the head of a turtle and a writing brush in one hand about to tick the name of the champion candidate. An otherwise unknown woman, Zhu Ying, embroidered the portrait shown here. The god is vividly presented in the form of a ghost with a writing brush in one hand and a gold ingot in the other. The picture reflects the high embroidery skills of young women in the middle period of the Qing dynasty. An inscription by Gu Zhichang is embroidered at the top.

PAINTING AND EMBROIDERY

御製四德論四德續論

B: 863

102

Imperial *Kesi* Album of Calligraphy
(Cover and introduction shown)
Qing dynasty, Qianlong reign period
28 x 17.5 cm

'Essay on the Four Virtues' was written by
the Qianlong emperor and in the introduc-
tory remarks to the text he writes:
'Yesterday I was at the Summer Resort, …
I felt ashamed of not living up to the name
of virtue … so now I would like to expound
my views on the issue.' These album pages
made with silk tapestry *kesi* technique were
modelled on the original copy, which must
have been in the Qianlong emperor's hand-
writing. *Kesi* technique allows for neat and
meticulous work which can accurately
reflect the intent of the original author.
The binding of the album is exquisite, with
the front cover and the introduction
decorated with dragon designs. It is clear
that this album was an item in the collection
of the Qing imperial palace.

四得論

昨自避暑山莊迴至清園
之作有慚愧德無稱四得
之句筆引而未嘗莊乃敘
而論之

夫子思引孔子之言以為
位祿名壽皆因流而得之
則知有德而得之者為實
無德而得之者為虛君子
至其實而得其宮其慚愧

也十翼為孔子作不應繫辭有
是語且上繫第十一章莫大
乎富貴莫大乎聖人又莫大
矣歐陽備以擇之不精繁衍叢
脞近於戰國後語疑十翼為襍
取後世講師之說非孔子所作
亦不為至見論咸傳思及此
筆按於後 濡筆

103

Kesi **Picture of a Woman**

Qing dynasty, Qianlong reign period (1736-1795)

104 x 40 cm

In this masterly Qing dynasty *kesi* picture we see a female beauty reclining on her bed, leaning on a zither with her chin in her hands. Outside her round window the peach blossoms are in full bloom. Such spring vitality contrasts sharply with this woman's boredom and loneliness, the subject of many a Chinese poem. Whether it is because she lives a reclusive life in the women's quarters so that she does not see many people or whether she is regretting persuading her husband to seek a high official position faraway, we cannot but feel pity for her implied loneliness. Owing to the extensive use of fine pattern lines this possesses the qualities of a good painting.

PAINTING AND EMBROIDERY

LIST OF ILLUSTRATIONS

1 Large bronze *jian* with phoenixes
2 Bronze *hu* inlaid with gold and silver
3 Bronze mirror
4 Bronze deer
5 Gold and silver inlaid bronze *hu* vessel
6 Gold animal
7 Bronze ox lamp
8 Gilt-bronze ink slab and cover
9 Bronze lamp
10 Chased gold quatrefoil dish
11 Gilt-bronze stupa
12 Gilded bronze buddhist triad
13 Gold bodhisattva
14 Gold model altar
15 Gold pagoda
16 Jade *cong*
17 Jade *cong*
18 Jade *pei* pectoral
19 Jade wine cup
20 Jade dragon *pei*
21 Jade *bi*
22 White jade hairpin by Lu Zigang
23 Jade calligraphic album of Hong Fan by the Imperial Brush
24 Jade calligraphic tablets "in imitation of Wong Xizhi by the Imperial Hand"
25 Jade brush washer in archaic style
26 Jade imperial calligraphic album
27 Jade *ruyi* sceptre
28 Three jade animals
29 Jadeite court beads
30 Neolithic pottery pot
31 Southern green glazed pot with mythical animal design
32 Red pottery pole stand
33 Moulded grey pottery bricks with animals of the four directions
34 Grey pottery brick with design of a winged immortal sporting with a dragon

35 Grey pottery brick with design of a winged immortal sporting with a tiger

36 Grey pottery female dancer

37 Grey pottery tomb figure of male dancer

38 Underglaze copper-red *meiping*

39 White glazed jar and lotus leaf shaped cover

40 White glazed *meiping* with inscription

41 Underglaze copper red plate with flower design

42 Blue and white brush washer with floral design

43 Blue and white floral *bianping* flask

44 Blue and white tripod *ding*

45 Blue and white dragon bowl

46 Blue and white dish with 'Three Friends of The Winter' design

47 Gold decorated yellow glazed jar

48 Blue and white dragon jar with cover

49 Peach bloom water pot with incised dragon design

50 Blue and white fish-dragon bowl

51 Large blue and white flower pot

52 Blue and white *zun* vase

53 *Doucai* decorated flower pot

54 Underglaze green *wucai* decorated flower pot

55 Hexagonal *ru*-type *zun* vase

56 *Guan*-type flattened *hu* vase

57 *Ru*-type glazed jar

58 Pale blue glazed and *doucai* bowls with floral roundels

59 Reverse-decorated blue and white dragon stem bowl

60 Yellow underglaze hexagonal dragon vase

61 Celadon double gourd vase

62 Blue and white peach dish

63 Gold decorated blue glazed reticulated revolving vase with the Qianlong Emperor in a hunting scene

64 Blue and white ewer and lid

65 Imperial engraved porcelain album with scenes of cotton growing and processing

66 Blue and white dragon dish

67 Hundred-deer '*famille-rose*' *zun* vase

68 '*Famille-rose*' square *zun* vase

69 Celadon brush washer with dragon handles
70 Group of feather holders
71 Carved lacquer Daoist emblems
72 Imperial carved lacquer box with lid
73 Carved lacquer monkey dish
74 Painted *ruyi*-shaped lacquer box and lid
75 Carved lacquer barbed dish
76 Imperial carved lacquer throne
77 Carved lacquer *ding*
78 Carved lacquer imperial sutra box and lid (with sutras inside)
79 Carved lacquer imperial box and lid
80 *Duan* inkstone
81 Yellow sandalwood carving of a standing Buddha
82 Bamboo carving of a fisherman
83 Bamboo brush pot by Zhu Songlin
84 Bamboo brush pot by Pu Zhongqian
85 *Cloisonné* animal handle censer
86 Red sandalwood relief carved flower vase
87 Wood carving of an ascetic
88 *Duan* inkstone by Gu Erniang
89 Bamboo carving of Zhang Guolao riding on a donkey
90 Carved rhinoceros horn cup
91 Boxwood *ruyi* sceptre
92 Archaistic red sandalwood *guang* vessel with silver inlay
93 Mahogany *ruyi*-shaped box with lid
94 Mahogany brush washer
95 Imperial painting of birds by the Song Huizong Emperor
96 Embroidered picture of Bodhidharma crossing a river
97 *Kesi* picture of Buddha
98 Embroidered portrait of Guanyin by Guan Zhongji
99 Embroidered picture of willows and horses by The Gu Family
100 Imperial *kesi* album of landscapes
101 Embroidered picture of the God of Literature
102 Imperial *kesi* album of calligraphy
103 *Kesi* picture of a woman